101 EXPER-IMENTS IN PHOTO-GRAPHY

101 EXPER- IMENTS IN PHOTO- GRAPHY

RICHARD D. ZAKIA
HOLLIS N. TODD

Rochester Institute of Technology
College of Graphic Arts
and Photography

Morgan & Morgan, Inc., Publishers
Dobbs Ferry, N.Y. 10522

Other books authored:

Rickmers, A.D., and Todd, H.N., *Statistics: An Introduction,*
McGraw-Hill, New York, 1967
Todd, H.N., and Zakia, R.D., *Photographic Sensitometry,*
Morgan & Morgan, Dobbs Ferry, New York, 1969
Dowdell, J.J., and Zakia, R.D., *Zone Systemizer,*
Morgan & Morgan, Dobbs Ferry, New York, 1973
Zakia, R.D., and Todd, H.N., *Color Primer I and II,*
Morgan & Morgan, Dobbs Ferry, New York, 1974
Zakia, R.D., *Perception and Photography,*
Prentice-Hall, Englewood Cliffs, N.J., 1975
White, M., Zakia, R., and Lorenz, P., *The New
Zone System Manual,*
Morgan & Morgan, Dobbs Ferry, New York, 1976
Stroebel, L., Todd, H., and Zakia, R., *Visual Concepts
for Photographers,*
Hastings House, New York, 1978

Contributing authors to the following books:
Neblette, C.B., *Fundamentals of Photography,*
Van Nostrand-Reinhold, New York, 1969
Photographic Systems for Engineers,
Society of Photographic Scientists and Engineers,
Washington, D.C., 1969
Struge, J. (ed.), *Neblette's Handbook on Photography
and Reprography,*
Van Nostrand-Reinhold, New York, 1977

MORGAN & MORGAN, Inc., Publishers
145 Palisade St. Dobbs Ferry N. Y. 10522
Standard Book Number 87100-001-6
Library of Congress Catalog Card Number 70-86657
Printed in U.S.A.

Acknowledgement is made to Mr. John Durniak for his suggestion some years ago to provide a series of experiments in photography that would be easily available to persons with an interest in photography. This book is an outgrowth of his original suggestion.

My special thanks to Barbara Morgan, one of the first woman artists to pioneer in photography, whose charm and magic have set the whole world dancing in front of her camera.

Richard D. Zakia
May, 1978

CONTENTS

LIGHT AND OPTICS 3

MEASUREMENTS 9

SENSITOMETRY 13

PHOTOGRAPHIC CHEMISTRY 29

OPTICS AND IMAGE QUALITY 41

PICTORIAL EXPERIMENTS 75

VISION AND ILLUSIONS 81

CONVERSION TABLE
EQUIPMENT LIST
CHEMICAL LIST 93
REFERENCES 97
GLOSSARY 101

INTRODUCTION

Photography is only about a century and a quarter old. During that time, chemists, physicists, electrical and mechanical engineers, as well as psychologists and artists, have developed photography to a remarkable level and scope. Photography is nearly unique in its blending of almost every human talent and skill into a workable system. Anybody, no matter what his interest, can discover in photography a challenging and stimulating field.

The experiments in this book sample some of the arts and sciences that make up photography. By carrying out these experiments, you will discover something about light, about the chemistry and physics that are part of the photographic process, and about the psychology of vision.

You can complete some of the experiments in a few minutes, but such experiments are not at all trivial on that account. It may take you hours or days to finish other experiments, and many experiments could be expanded to take months or forever to finish.

We have deliberately avoided writing the experiments like a cookbook. One of the fascinations of photography is that the exact results are almost never predictable. Thus every one of the experiments is real because nobody knows in advance what the "right" answer is. After you do the experiment, you will know the answer. Partly for this reason, and partly to give you the pleasure of working out the experimental details, we have not given 1-2-3 instructions, and we have not often indicated what the answer ought to be. The rule is: *find out for yourself.*

Also, we have included very little explanatory material. If you run across terms that are unfamiliar to you, consult the glossary and the references listed near the end of the book.

You will find most of the equipment and materials needed for the experiments in a well-equipped darkroom. Some chemicals you will perhaps need to obtain from a friendly high school chemistry teacher or through a local camera club. A few items

you will need to buy specially; we give sources for these items.

You may choose experiments which interest you, and in almost any sequence. You surely should tackle those which involve measurements of photographic images, including Experiments 9 and 10. Without measurements it is hard to get reliable experimental data. If you intend to go far in photography, you should begin making measurements immediately, even if your interest is primarily in the art rather than in the technique of photography.

Keep a record of your experimental work in a bound (not looseleaf) book. Write down your experimental plans, your procedures in detail, and the results of your work. At the end of each experiment, write a summary of your findings. Use library paste to secure the images you want to keep. (Cellulose tape and rubber cement in time fail to hold.)

Such a record will in time be valuable for reference. If you are a student, it will show your ability to work on your own, and your interest in other than school subjects. If you hope to go to college, you will find that college admissions officers are greatly impressed by such evidence.

Many colleges offer programs in photography, often in connection with art or journalism. A few colleges offer degree programs in photographic science and technology. For a list, write directly to Eastman Kodak Company (Dept. 841) 343 State Street, Rochester, New York 14650. Ask for "A Survey of Photographic Instruction" AT-17.

Richard D. Zakia
Hollis N. Todd

LIGHT
AND
OPTICS

1.CAMERAS WITHOUT LENSES

Beautiful pictures can be made with a camera which has no lens.
Use a cigar box as the camera body.

1. Make (drill or cut) a hole about 1 inch across in one end of the box.
2. Cut a piece of aluminum foil a little bigger than the hole.
3. Make a clean hole in the middle of the foil with a #10 sewing needle.
4. Tape the foil over the hole in the box.
5. Draw sight lines on the top and the side of the box to serve as viewfinders.
6. Stick a bit of black tape over the hole in the aluminum.

In a dark room or closet, tape a strip of 35mm or 120 size or similar film to the far end of the box. Seal the box cover with black tape so that it is light tight.

Choose a subject with near and far objects, to take advantage of the great depth of field this camera has. Exposure time outdoors even with a fast film (exposure index 400) will be about two

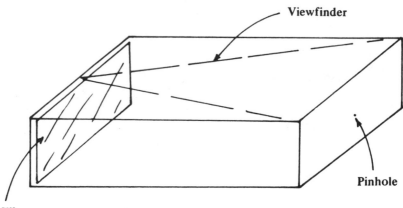

Viewfinder

Pinhole

Film

PINHOLE CAMERA

seconds, so if the scene includes a person he must remain still. To make the exposure, remove the bit of tape over the hole, and replace it at the end of the required time. Process the film in your usual way and print it.

The f-number of your camera is found as usual by dividing the pinhole diameter (about 0.02 inches) into the camera length, about 8½ inches, so the f-number is about 400.

Would you get better images if the film plane were curved? Can you make a wide-angle pinhole camera? If you are mechanically skillful, you can make a pinhole camera with rising and falling front. It has been done.

2. MORE PINHOLE EXPERIMENTS

Make cameras from coffee cans or oatmeal boxes.

Does it make a real difference in the image if the interior is blackened or not?

Can you make a pinhole so small that the image is, agreeing with diffraction theory, inferior to a larger one?

What happens to the image when you use two slightly separated pinholes?

Try a thin slit instead of a pinhole for an aperture. Observe the effect on variously oriented lines in the subject.

3. PATTERNS OF LIGHT

In thin aluminum foil, make a straight cut about an inch long with a sharp razor blade. From a distance of about 10 feet, look through the slit at a candle flame. (Any other small source will do, such as a distant street lamp. Broad sources will not do.) You will see a fairly broad pattern of light and dark bands, including faint colors. Sketch the pattern. Pull slightly on the foil at the sides of the slit, so as to make a wider aperture. You will see the pattern shrink. These observations are related to the wavelike behavior of light, and involve diffraction and interference. Look at similar sources through: a piece of window screen; a silk stock-

ing; a feather. Here you see the effects of many small apertures. Make sketches. Explain the production of colors. See a general

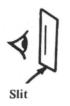

Slit

Candle

physics text under "interference" for a discussion of these phenomena.

4. RAINBOWS

Look at light sources with a diffraction grating (Edmund Scientific Co., Barrington, N.J. 08007; order #40,272–$.25.) Make a slit 1″ x 1/8″ in a card about 4″ square. Prop the card in front of a lamp. From a few feet away, look at the slit through the grating, holding the grating close to your eye. You will see two brilliant spectra, like rainbows, one on either side of the central image of the slit. If the spectra do not appear, rotate the grating 90°.

Look at tungsten lamps, a candle flame, a fluorescent lamp. Sketch the patterns, indicating the relative brilliance of different parts of the spectrum.

Examine neon and other advertising signs. Try sodium and mercury highway lighting lamps (you will not need to use the slit.) Interesting color photographs can be made with the grating over your camera lens. Night scenes work best.

5. INVERSE SQUARES

Cut an aperture 1″ square in a piece of aluminum foil, using a razor blade. On an 8½″ x 11″ sheet of white paper rule a grid of 1″ squares. Using a candle flame as a light source, find the relation between the distance you hold the aperture from the candle, the

distance the grid is from the candle, and the size of the spot of light on the paper.

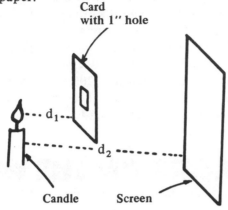

Try the same experiment with a fluorescent lamp. You will have a little trouble estimating the size of the patch of light, but do the best you can. What is the relation between distances and spot size in this case?

When does the "inverse square" law hold? (Look up the law in a physics text.)

6. TEASPOONS AND MIRRORS

Lenses and mirrors are related, in the sense that they form images in similar ways. A new teaspoon has a shiny inner—concave—and an outer—convex—reflecting surface. Both of these surfaces form images. Try first the convex surface. Put a pencil on the surface, then move it toward you, observing the image of the pencil tip. Do the same for the concave surface. Note that there are two different images in the second case, and that where they switch you see only a blur. The position of the pencil point where the

image blurs is approximately the focal length of the concave mirror. Since teaspoons are not spherical ordinarily, they have two different curvatures at least, and thus the images formed are not too good. In fact, the images are astigmatic. Interesting pictures can be made of the images formed by shiny teapots and coffee pots and bowls and other kitchen gadgets.

Astronomical cameras, such as the 200-inch Mt. Palomar instrument, use mirrors as the major optical elements. Look up the appropriate article in an encyclopedia for sketches of the operation of this and similar cameras.

7. MIRRORS ON THE WALL

Many barbershops have facing mirrors. Find out how many images of yourself and your camera you can get in one shot. Think about what distance to focus on. Some of the images are very far away, some are close. Think about the necessary depth of field.

Some clothing stores have triple, adjustable mirrors. Try different positions of the mirrors to see what effect the mirror positions have on the number and orientation of the multiple images. Make photographs of the most interesting arrangements.

8. WHERE THERE IS LIGHT THERE IS HEAT

Slide projector temperatures can get higher than you think. Use a metallic oven thermometer (not fluid-filled) to measure the temperature (a) in front of the projection lens; (b) at the spot where air leaves the lamphouse; (c) in the slide carrier. Would you expect a dense slide in the carrier to be the same temperature as that which you measured? Would a color slide get as hot as a black-and-white slide?

9. GADGET BAG DENSITOMETER

You can measure black-and-white print densities by the use of a reflection gray scale. In a piece of black paper, cut a notch about 1″ x ¼″. Choose the print area to be measured. Put the black paper over the print so that the area is visible at the inner part of the notch. Place the gray scale alongside, under the black paper. Slide the gray scale along until you get a match with the print area. You may have to estimate between patches.

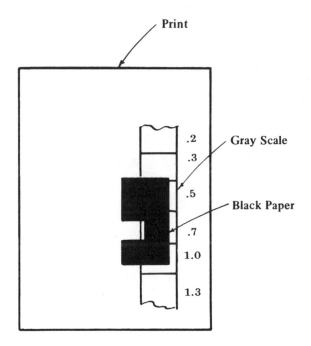

This method works better than you might suppose. Four sample patches were measured by three different observers, and the

results compared with the data obtained from a $700 physical electronic densitometer. Here are the results:

	OBSERVER		AVERAGE READING	READINGS FROM DENSITOMETER
1	2	3		
0.12	0.05	0.08	0.11	0.08
0.25	0.15	0.28	0.22	0.20
1.40	1.40	1.50	1.43	1.44
1.80	1.80	1.80	1.80	1.84

Not bad! Try this method out, making three or four independent judgements and averaging the data.

10. PORTABLE TRANSMISSION DENSITOMETER

Make a transmission densitometer, useful for measuring negatives and transparencies from a sensitive CdS light meter. Place a small

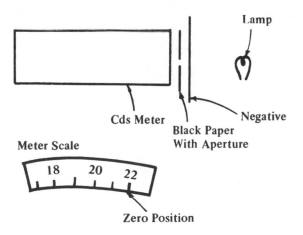

(1/8″) aperture in black paper over the cell window. Place a 50-watt clear tungsten lamp an inch or two from the aperture, so that the needle comes to a mark on the high end of the scale. This is the zero position. On the EVS scale of markings, each change of a full number represents a change in light level of 2 times, and thus a density of 0.3 (the logarithm of 2). You can estimate easily to the nearest tenth of a density unit. Place the desired negative area over the aperture, and read the density immediately. You may have a little trouble locating the negative area accurately, but the problem is small with a gray scale image.

SENSI-TOMETRY

11. OVEREXPOSURE AND OVERDEVELOPMENT

Many photographers find it hard to distinguish between overexposure and overdevelopment, and between underexposure and underdevelopment

Pick a "normal" subject—portrait or landscape. On a 12-exposure roll of film, make an exposure series: ¼ normal, ½ normal, normal, twice normal, four times normal. Then leave a space and repeat the series. Cut the roll in half. Develop one piece normally, and the other twice the normal time. Look carefully at the negatives. Underexposed negatives will have thin flat shadows in both development sets. Overexposed negatives will have very rich shadows in both sets. Highlights and midtones will be normal in the normally-developed strip and will be dense and contrasty in the overdeveloped strip. Especially compare the underexposed and overdeveloped negatives with normally exposed and normally developed negatives. Your conclusion will be that overdevelopment cannot compensate for underexposure, or else!

12. MORE OVEREXPOSURE AND OVERDEVELOPMENT

This experiment is a lot of work, and worth it only if you are really serious about understanding the photographic process. From Experiment 11 you have 10 negatives.

Make the best print you can from each of them. Change paper grade and exposure time as necessary. In every print, match the highlight tone. Compare the midtone and shadow reproduction in the ten different prints.

Possible conclusions:

What you thought was normal negative exposure may have been over or underexposed. That is, you may be able to make excellent prints from negatives which have been exposed at exposure indexes other than what you have been using.

Or—you may have been underdeveloping your negatives. You may discover that "overdeveloped" negatives give more pleasing pictures.

3. REDUCE FILM SPEED

The ASA film speed rating for films is intended to give you a negative that will provide an excellent print with the least amount of camera exposure. If you are willing to use a number lower than the ASA rating you can increase the shadow detail of your print. Try it. First select a scene that has good shadow detail and then shoot one picture at the rated film speed, ½ the rated speed and ¼ the rated speed. More if you desire. Example: if the film is rated at 125, try 125, 60, 30, 15. Make a print from each of the negatives and compare. Include a reflection gray scale if you want to make measurements. What are the disadvantages in using speeds lower than those for which the film is rated?

14. TWO-TONE
ZONE SYSTEM

In order to be able to print every negative on a single paper grade, say #2, you need:

1. To measure the range of the subject from darkest important shadow to lightest important highlight;
2. To process the negative to a contrast index appropriate to the scene.

This method will work only if the negative is properly exposed as discovered in Experiment 11.

METHOD FOR METERS USING THE EVS SYSTEM

Aim the meter at the darkest shadow in which you want to hold detail. Note the reading. Do the same for the highlight. Take the difference in the readings, and multiply by 0.3. If you get 2.2, you are working with an average scene, and the usual contrast index of 0.60 will come close. There is nearly an inverse proportion between the required contrast index and the number you have computed, as in the following table:

EVS DIFF.	x 0.3	REQUIRED CONTRAST INDEX
5.0	1.5	0.90
7.5	2.2	0.60
10.0	3.0	0.45

Follow the manufacturer's recommendations for your film and developer to get the necessary Contrast Index.

METHOD FOR METERS MARKED WITH ARITHMETIC SCALES

If your meter scale is marked 6.25, 13, 25, etc., measure the subject in the same way as above, and count the scale intervals. From 6.25 to 25 is two such intervals. Multiply the number of intervals by 0.3 and proceed as above.

15. CONTRAST

Density differences in a negative are good measures of negative contrast. In this experiment you will discover how contrast changes with negative exposure level.

Use the gray and white neutral test cards as subjects. Light them equally. Make an exposure series of this test subject, normally exposed and both under and over exposed. After processing, measure the negative density values by the method of Experiment 10. Find the difference in density values for each negative. Make a graph, showing how the density difference (contrast) varies with stops under and over normal.

16. GAMMA

Gamma is described as the slope of the straight line portion of the Density vs Log Exposure curve. A quick way to measure gamma of a film that has been exposed in a camera is to photograph a gray and white card side by side. Exposure should be based on the gray card. After processing, measure the densities (see Experiment 10). The density for the gray card should be at least 0.40.

Divide the density difference by 0.70. This will give you the approximate gamma to which the film has been processed.

Example: if the density of the white card is .90 and the gray card 0.50, the density difference is 0.90 minus 0.50 or 0.40.

$$\frac{0.40}{0.70} = 0.57 = gamma$$

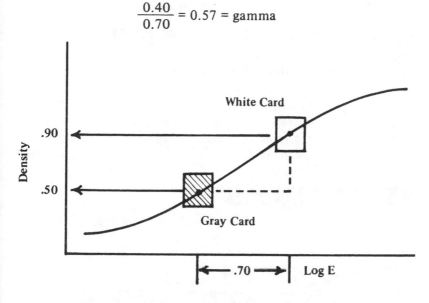

17.CONTRAST COMPENSATION

In principle, you can make a high-contrast negative and a low-contrast negative of the same scene and compensate in printing to get about the same print from both negatives. (This is the justification, in part, for having papers of different grade numbers.)

To test the validity of this principle, choose a normal subject of limited tonal range, such as a well-lighted model.

Make three negatives. Process one 50% less than your normal time; process one normally; process one for 150% of your normal time. Attempt to make matched prints from each of the negatives by changing paper grade and printing time as needed. Match the

midtones carefully, and examine the shadows and highlights in each of the prints.

If you use roll film for this job, it is well to leave a blank frame between exposures so that you can cut them apart in the dark without likelihood of damaging the images.

18."THE SAME" IS NOT QUITE THE SAME

On each of seven successive days make a print of a negative gray scale on the "same" paper grade, exposed and processed "the same." Line up the seven images and compare them. How many are identical, as nearly as you can tell? Is there a trend; i.e., is there a gradual reduction or increase in density? Using the method of Experiment 9, estimate the density of a midtone, of a highlight, of a shadow. Which shows the most change? Is the change in contrast (estimated by the difference in density from highlight to shadow) more, or less, noticeable than the change in density of a given patch?

19.DENSITY SCALE AND EXPOSURE SCALE FOR PAPERS

For papers of the same surface characteristics, different grade numbers produce nearly the same range of *tones*. What is different about different grade numbers is the range of *exposures* over which they can operate. This range is called the exposure scale. Test your papers by this method.

Make a print, by contact or enlargement, of the Negative Step Tablet. Count the number of visibly different patches in the print. Subtract one. Multiply this number by 0.15. The answer is the approximate exposure scale. It is about equal to the density difference (from shadows to highlights) that a negative must have to print well on that paper grade.

20. SHADES OF H&D*

The "characteristic curve" of a photographic material shows the relationship between input (logarithm of exposure) and output (density). You can find the characteristic curve of a photographic paper by this method.

Use a negative step tablet as input data. Make a print in your usual manner. The image should contain at one end a blank white and at the other a maximum black. If not, change the exposure time appropriately and make another image.

Measure the image densities using the method of Experiment 9. Plot the resulting data this way: on the horizontal axis, a scale of step tablet densities, but in reverse of the normal order, i.e., from large to small as you read from left to right. (You do this because big densities mean small amounts of light on the paper.) Use the same scale for the print densities, running upward in the conventional way on the vertical axis.

Plot the points, and draw a smooth curve representing the data. You will probably miss some points with the line because of experimental error.

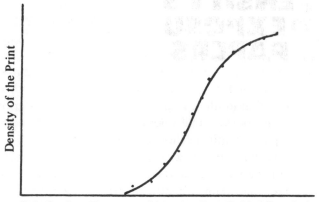

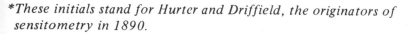

Relative Log Exposure (Negative Step Tablet Density)

(vertical axis label: Density of the Print)

These initials stand for Hurter and Driffield, the originators of sensitometry in 1890.

21. MORE CHARACTERISTIC CURVES

Follow the method of Experiment 20 with variations.

For example, change processing time above and below your normal usage, and see the effects on the curves.

Try papers of different grade numbers.

Try papers of different surface characteristics, e.g., glossy and matte.

22. DEVELOPMENT COMPENSATES FOR EXPOSURE

When you make a print, you can sometimes avoid filling the waste basket with scrap prints. The trick is that increased development time will compensate for moderate errors in the underexposure direction. (This trick is usually not good for negative materials.)

Check this out as follows: make a print using a negative step tablet as the original. Process normally. Your image should show clear whites and deep blacks. If not, change the exposure time in the required direction. Now make another print with 25% less exposure time and process for twice the normal time. Look at the prints, placing them side by side. You will have a near match of tones, if you are lucky.

For more sophisticated experimentation, measure the print tones, using the method of Experiment 20, and plot the results against the negative values. The two curves you get will be almost the same shape, just displaced laterally. This result means that the "speed" of photographic papers increases with increased development time, thus compensating for underexposure.

Notice that it takes a big increase in development time to make up for a small exposure error, so there is a price to pay for a mistake in exposure.

23. EQUAL INTERVAL GRAYS

Make an equal-interval set of gray tones. (This is a difficult experiment.)

Refer to your results from Experiment 20. Divide the density range into five equal intervals. Find from your characteristic curve the corresponding negative density intervals. Take the antilog of each of these intervals. These numbers are the exposure factors which must be applied to give an equally spaced set of tones.

Find by experiment the exposure time, with no negative in the printer, which gives a just-barely-off-white. Use the factors you have computed to get the other tones.

You may use this little table of antilogs:

NEGATIVE DENSITY INTERVAL (LOG)	EXPOSURE FACTOR (ANTILOG)
0.1	1.3
0.2	1.6
0.3	2.0
0.4	2.5
0.5	3.1

If by experiment you find that the just-off-white is produced with an exposure time of 8 seconds, and the density interval to the next tone is 0.2, you would use a factor of 1.6 x 8, and get about 13 seconds as the required exposure time.

24. RECIPROCITY LAW FAILURE

When you change the f-number of your lens, you usually suppose that if you change the shutter time appropriately you will obtain the same image densities. This is the reciprocity law. It works over a limited range, but fails if the change is very great.

Test an enlarging paper for reciprocity-law failure. Make an image of a negative step tablet with the enlarging lens wide open, using an exposure time that gives a good image of the step tablet.

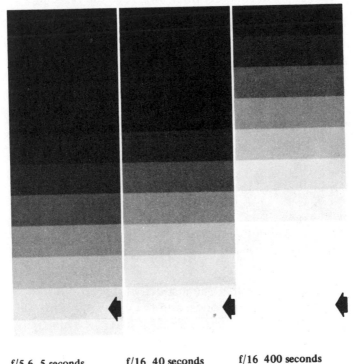

f/5.6 5 seconds f/16 40 seconds f/16 400 seconds
 (+ 1.0 N.D. Filter)

RLF If there were no RLF the 3 grayscales would be identical.

Make other images, stopping down the lens 2 stops, 4 stops, etc., as far as you can go, and increasing the exposure time by factors corresponding to the change in lens aperture. Trim the images and place them side by side. Any failure of the images to correspond indicates reciprocity-law failure (assuming that process variability is not a problem. Thus, be careful about adhering to processing times and temperatures and agitation conditions.)

If the images can be made to match by a lateral displacement, the amount of reciprocity-law failure is measured by the number of steps displacement. One step is ½ stop; two steps is one stop, and so on.

25. SOLARIZATION

With some photographic materials, added exposure can cause a decrease rather than increase in density. This effect is called *solarization*.

Try a slow enlarging paper first. Adjust your enlarger so that at the smallest aperture and a few seconds exposure time you get a faint density after processing. Now make an exposure series, opening up the lens one stop at a time. When you reach your widest aperture, continue the series by doubling the exposure time. Process the strips and examine them. Solarization is shown by a decrease in density for some patches. Measure the densities and plot them against log exposure; the intervals on the log axis will be 0.3.

Try different types of photographic papers. Contact papers solarize well, but you had better use a light source stronger than that of an enlarger.

26. SOLARIZING FILM

Most modern films are hard to solarize. Slow films work better than fast films. One of our students produced solarization by aiming his camera out a window and leaving the shutter open for a whole weekend.

Try this: shoot a scene that is lit by a *bare* (non-frosted) tungsten lamp; include the lamp itself in the field of the lens. Expose

one frame normally, one 100x normal and one 10,000x normal. Process as usual and examine the negatives. If solarization occurs, the image of the filament will be less black in the negative than other parts of the scene. Print these negatives.

27. PRINT IN A CAMERA

Use fast enlarging paper instead of film in your camera. You can cut the paper to fit and load the camera using an appropriate safelight. You will need to experiment to find the right exposure conditions. Start with an exposure index of 2.

If you use variable-contrast paper, you can change the image contrast by using filters just as you do in the enlarger. Try a variety of subject matter, of different colors, so you can see how they are affected. See Experiment 62.

Experiment to discover how much variation in exposure you can afford and still get a good print.

Make contact prints of your paper negatives. You will obtain prints with interesting textures.

This experiment is very similar to the first photographic method ever invented.

**A PICTURE MADE ON PHOTOGRAPHIC
PAPER EXPOSED DIRECTLY IN A CAMERA**

28. YOUR OWN VARIABLE CONTRAST PAPER

Some conventional enlarging papers can be made to give reduced contrast by the following method:

1. Print a negative on a paper grade that is too hard to respond to all the negative tones. Print so that the highlights are reproduced well. The shadows will be too dark and flat.

 2.Before processing, give the image (without the negative) a big
blast of light through a red filter. Red cellophane or plastic
will do. Use a photoflood, a foot away from the paper, and a
time like 20 seconds.

 3.Process the print.

The reduced contrast is associated with the Herschel Effect,
named after the scientist who described this phenomenon. Photo-
graphic references will give you more information about this pro-
cess.

 Slow enlarging papers work better than fast ones. If you give
more red light exposure, the effect is greater. With care, you can
make a #2 paper out of a #5 paper.

29. HIGH AND LOW FIDELITY

The over-all system performance can in part be described by a
tone-reproduction curve. Use a reflection gray scale as a subject.
See that it is lighted uniformly. Make a negative. Print the nega-
tive. Measure the print densities by comparison with the original
gray scale as in Experiment 9. Graph the resulting data, putting
the numbers from the original gray scale on the horizontal axis
and the numbers from the print scale on the vertical axis. The
resulting graph is typically S-shaped, indicating that at least some
factors in the photographic process operate so as to make strictly
correct reproduction difficult, if not impossible. What type of
curve would you have for perfect reproduction? You can use this
method to see what happens when you change negative exposure
and development, or what happens when you change printing
paper grade or exposure.

30. THE THIRD GENERATION PRINT

A copy print is usually poorer than the original. A copy of a copy is even worse. See what happens when you make such a sequence of prints.

Use as a subject a good print with sharp detail. Fasten it to a vertical wall, and put alongside a gray scale. Illuminate the print and gray scale evenly. Make a negative of the print, and a second print from that negative.

Repeat this process.

Measure and plot the gray scale values, for each of the two copy prints. Look critically at the detail in the prints to see how it has changed.

SAFETY TIPS

The following experiments (31-45) involve photographic chemistry. Most of the chemicals are harmless, but you should take sensible precautions to avoid hurting yourself and damaging your equipment. Good work cannot be done in a dirty darkroom or when your hands are dirty.

1. Work slowly and carefully to avoid spilling chemicals and solutions.
2. Sponge spilled materials immediately. Rinse the sponge well.
3. Keep your hands clean. After washing, dry your hands with a clean towel.
4. Manipulate prints during processing with plastic tongs.
5. Assume that every chemical is hazardous. Keep your hands away from your clothes and from your face.*
6. Use plastic goggles to protect your eyes when you mix chemicals or process photographic materials.

Refer to the Chemical List on page 95 for chemicals which may be injurious.

PHOTO-
GRAPHIC
CHEMISTRY

31. NON-SILVER PHOTOGRAPHY

Non-silver photographic processes are very old. The scarcity of silver is stimulating renewed interest in such processes. This experiment uses the sensitivity to light of some iron chemical compounds.

Make two separate solutions: (1) 40% ferric ammonium citrate (2) 10% potassium ferricyanide. BE CAREFUL—these solutions are poisonous. A 10% solution takes 10 grams of chemical to be made up to 100ml of solution; a 40% solution takes just 4 times as much chemical. (See table of equivalents in the appendix.)

Mix the solutions in equal amounts just before use. Float (in the dark) a sheet of white typing paper on the mixed solution, drain, and hang to dry in the dark.

Expose the dry sheet to a negative in a contact frame, or under a sheet of glass. You will need a great deal of light—a few minutes of exposure to strong artificial light, and a few seconds to direct sunlight.

Process in a solution of 15ml vinegar to 250ml of water. Rinse in clean water and dry. You have made a "blueprint" by a process often used to reproduce engineering drawings.

32. MORE NON-SILVER PHOTOGRAPHY

Chromium compounds, like those of iron and silver, can be made sensitive to radiation. Some chromium processes maintain a place of commercial importance, as in some graphic arts applications. Kitchen-sink recipe: make a solution of gelatin in water: one tablespoon of plain gelatin soaked for 20 minutes in a cup of cool water, then warmed gently to promote solution, with stirring. Watch for scorching. In the dark, add 2 tablespoons of potassium dichromate, and stir until dissolved.

Coat white paper as in Experiment 31 and dry in the dark. Expose the blueprint paper to sunlight. Wash in cool water for a few minutes—this completes the processing. Expect a brownish low contrast image.

33.OLD-TIME DEVELOPER

It was just about a century ago that Ferdinand Hurter and Vero Driffield began their researches into the behavior of photographic materials. Their notebooks indicate that they worked with a very simple developer: 4 parts by volume of a saturated solution of potassium oxalate and 1 part by volume of a saturated solution of ferrous sulfate. Try out this developer, making stock solutions and mixing the two parts just before processing. Since this developer is relatively slow-acting, you will need a long development time, of the order of 15 minutes. Also, you will find that your film speed will fall, so that you will need to increase camera exposure by two or three stops at least.

Do you find it to be true, as Hurter and Driffield claimed, that this developer gives no fog density? If so, this would be a good developer to use with outdated film perhaps.

34.COMPATIBILITY

Materials used in the manufacture of cameras and processing equipment must not adversely affect the image. Some materials are sensitizers—they make emulsions more sensitive to radiation. Other materials are desensitizers. Often the same substance can act either way, depending on the conditions. Usually moisture is needed to show the effect.

Tape solid materials to a sheet of photographic paper under safelight conditions. Place a drop of water under some samples. Wrap against light, and let stand for a week. Then process. Any detectable spot indicates the material was a sensitizer. Treat other sheets of paper in the same way, but give a fogging exposure before processing. Any light area indicates desensitization.

As materials try: steel wool; copper coins, silver coin; aluminum foil; bits of gravel; crystals of salt or sugar; hypo crystals; indelible pencil.

Try fluids (no water is needed) like rubbing alcohol; mercurochrome; iodine solution; food dyes.

35. LATENT IMAGE KEEPING

We can only infer what the latent image is from its properties. One of the characteristics of the latent image is that it changes with time. Usually the image fades; sometimes, under some conditions, it actually builds up. Temperature and humidity are two important environmental factors which affect the latent image decay or increase.

Expose 7 "identical" images of your negative gray scale on 7 sheets of photographic paper from the same package. Process one immediately. Wrap 3 images in each of two light tight packages. Put one package in the refrigerator. Keep the other package in as warm a place as you can readily find.

Process one image from each package after the following time intervals: 1 hour, 1 day, 10 days. Compare the images after development.

How will you solve the problem of processing variability? That is, how will you know that any differences in the images are really due to a change in the image characteristics, and not simply to changes in developer or processing conditions?

36. MORE LATENT IMAGE KEEPING

Repeat the latent-image-keeping experiment (#35) with this change; store the images at 100% relative humidity. A piece of dampened sponge will provide the water. The paper must not actually get wet, so you will need to hold it away from the

sponge. Try putting the sponge on the bottom of a throwaway aluminum tray, and using wooden dowels to support the paper above the sponge. Wrap the whole thing in black paper to exclude light. Follow the rest of the procedures of Experiment 35.

37. INTENSIFICATION

A trace of magic clings to some darkroom procedures, especially to the process of chemical intensification.

From Experiment 11 choose one of your negatives that was seriously underexposed. By the method of Experiment 10 measure the density of three tones: a shadow, a midtone and a highlight. Make the best print you can of this negative.

This intensification process involves three steps: hardening, bleaching, and redevelopment.

Hardening bath:
 250ml of water; 5ml of 37% formaldehyde; 30 grams of sodium carbonate. Dissolve and make up to 500ml with water.
 Bathe the negative in this bath for 3 minutes; fix in fresh fixer for 5 minutes; wash the negative thoroughly.
Bleach stock solution:
 400ml of water; 45 grams of potassium dichromate; 30ml of concentrated hydrochloric acid; dissolve and make up to 500ml with water. Make the working bath from 1 part of the stock and 10 parts of water.
 Bathe the negative in the working bath until it is completely bleached. Wash for 10 minutes.
Redeveloper:
 D-72, one part of developer to 3 parts of water. Redevelop in the light for about 10 minutes. Rinse, fix for 5 minutes, wash and dry.

Now, measure the same areas you did at the beginning. Which density increased the most? Which the least? Make the best print you can from the intensified negative. Are the results worth all the trouble?

38. SILVER REMOVAL

Try this recipe for reducing an overexposed negative. Choose one from Experiment 11 that has been normally processed but considerably overexposed. Measure a shadow, a midtone, and a highlight area of the negative. Make the best print you can from the negative.

Farmer's Reducer R-4a is often recommended for this task. You need two stock solutions:

A = 8 grams of potassium ferricyanide; make up to 100ml with water.

B = 50 grams of hypo; make up to 200ml with water.

1. Harden the negative as in Experiment 37.
2. Mix 30ml of stock solution A with 120ml of stock solution B, and dilute with water to 1 liter.
3. Bathe the negative in the diluted mixture. Use a white tray so that you can watch the process of reduction.
4. When you think the process has gone far enough, wash the negative and dry it.

Measure the same negative areas you did before. How did the densities change?

Make the best print you can from the reduced negative. Was the reducing process worth while? Did it correct for the negative overexposure?

39. MORE SILVER REMOVAL

Farmer's Reducer R-4b is supposed to improve an overdeveloped but normally exposed negative. Choose such a negative from Experiment 11. Measure and print the negative as in Experiment 38. Solutions:

A = 7½ grams of potassium ferricyanide; water to make 1000ml.

B = 200 grams of hypo; water to make 1000ml.

1. Harden the negative as in Experiment 37.
2. Bathe the negative in solution A for 1 minute.

3. Bathe the negative in solution B for 5 minutes.
4. Examine the negative. If it is not sufficiently reduced, repeat steps 2 and 3.
5. Wash the negative thoroughly and dry it.

Measure and print the reduced negative. Has it been improved? Compare the results from Experiments 38 and 39. Does reduction compensate for overexposure? for overdevelopment? for neither? Do you conclude that it is better to make a good negative rather than spend time trying to improve a poor negative?

40.TONERS

Altering the neutral color of black-and-white prints can help establish a mood. This is most easily done by using toners. Snow scenes can be toned bluish to appear colder, rustic landscapes brownish to appear warmer, etc. The easiest way to tone is to use packaged chemicals ready for dilution or simple mixing. One way to tone a print is to combine metal salts with potassium ferricyanide. Metals such as cadmium, uranium, iron, cobalt, molybdenum, copper and tungsten are often used.

You might try starting with Kodak Poly-toner. It is a brownish type toner producing tones which vary with dilution. Try these dilutions:

1 part toner, 4 parts water	tone for 1 minute at 70° F
1 part toner, 24 parts water	tone for 3 minutes at 70° F
1 part toner, 50 parts water	tone for 7 minutes at 70° F

Make four prints in an identical manner so they will match for contrast. Be sure to fix and wash them properly. Use a fresh fixing bath. Keep one print for a reference and treat the other three to various dilutions of toner. After the prints have been toned wash them as you normally wash prints and then dry them. Line up the untoned print and the toned prints and compare the results. Try different types of photographic paper. Try other toners such as Sulfide Sepia Toner, Rapid Selenium Toner, Brown Toner and Blue Toner. Keep a file of all the prints you tone along with appropriate data for future reference.

41. MONOBATHS

Ever wonder whether you could combine a developer solution and a hypo solution into a single solution and then develop and fix a sheet of film or paper in that single solution? A monobath does just this. W.D. Richmond reported his experiences with a Monobath as early as 1889, so it is not a new idea. Monobaths are many and varied in complexity.

Try this recipe introduced in 1957 by H.S. Keelan.

MONOBATH 438

Water (preferably distilled) at 120° F	700 milliliters
Hydroquinone	15 grams
Sodium sulfite	50 grams
Phenidone	10 grams
Potassium alum	18 grams
Sodium hydroxide (warning:caustic)	18 grams
Sodium thiosulfate	60 grams
Water to make	1 liter

Try this Monobath with a fine grain film such as Panatomic-X. A 4 minute development time at 68° F is a good place to start. Process the film in whatever container you usually use. If you use a developing tank try this technique. Fill your tank with the monobath in a lighted room. Go dark and stay dark. Load your film on a reel. Start agitation as the reel is lowered into the mono-bath. Agitate for about 15 seconds raising the film completely out of the monobath once during this period. Then agitate for 10 seconds every one minute interval. After the four minutes are up wash and dry the film as you normally do. Process only one roll of film at a time. If the dark requirement is not convenient then replace the top of the tank after the first minute and process in the light. If you want to increase contrast make the solution more alkaline, (use 50% more sodium hydroxide) or increase the quantity of hydroquinone.

For more on the subject see MONOBATH MANUAL by Dr. Grant Haist, Morgan & Morgan, Hastings-on-Hudson, N.Y. 10706

PRINT FROM A NEGATIVE PROCESSED IN MONOBATH 438

QUICKIE MONOBATH

As a starter you may want to try this easy-to-mix monobath. Add 10 to 25 grams of hypo to one quart of D-72 or D-19. Develop for about 5 to 8 minutes at a temperature between 70 to 75°F. Try a medium grain film (one having a speed of about ASA 100). If after development you find the contrast is too high, increase the amount of hypo; if too low, use less hypo.

42. A SIMPLE DEVELOPER

Good developer formulas need not be complicated. D-23 is an excellent fine-grain developer. It contains only two chemicals other than water. Compare the results from this formulation with your favorite fine-grain developer. See Experiment 59 for a method of estimating graininess.

D-23 DEVELOPER

Water (at about 125°F)	750 ml
Metol	7.5 grams
Sodium sulfite (desiccated)	100 grams
Water to make	1000 ml

Use D-23 undiluted. Work out your own development time, trying first 10 minutes at 68°F. Note: there may well be, as with other fine-grain developers, an effective loss in film speed when you develop in D-23.

43. SALT WASHES

Surprisingly enough, washing your prints in sea water instead of fresh water can reduce the amount of wash time required. Washing time for films can be cut about 30% and for paper prints, about 20%. If you are not around any sea water similar results can be obtained by mixing a 3% solution (3g in 100ml of solution) of table salt. (Sea water is about 2.6% sodium chloride.)

After you have washed your prints in the salt water you will want to remove the salt from the prints or film. Just wash the prints or films for about 3 minutes in fresh water.

Check to see if washing in salt water followed by a fresh-water wash is as effective as a fresh-water wash by washing two matched prints under each type of washing procedure, drying them together and then putting them in a hot and humid environment conducive to staining. Check to see if a fresh-water wash after the salt-water wash is really needed.

44. WHEN TO DUMP HYPO

A fresh solution of hypo contains no silver, but with each roll of film and sheet of paper fixed, silver is left behind and builds up as the hypo gets used. If the amount of silver becomes too great the hypo is not performing its function properly. To test this you need only a solution of sodium sulfide.

WHEN-TO-THROW-OUT-THE-HYPO TEST SOLUTION

Water	100 cc
Sodium Sulfide	2 grams

When ready for use dilute one part of test solution to nine parts of water.

Place a drop of this diluted test solution on a margin of squeegeed film or print. After about 3 minutes remove it with a clean white blotter or cotton. A staining in excess of a just-visible tint indicates that the films or papers are picking up the excess silver in the hypo. Dump the hypo or reclaim the silver from the hypo and sell it.

45. A SILVER RECLAIMER

Make yourself a little money by reclaiming silver from spent fixing baths. Store your exhausted fixer in a crock or plastic tub. Every now and then throw in a wad of steel wool. A simple chemical replacement reaction makes the silver precipitate out. After a few days, pour off the solution and dry the residue. When you get a few pounds of this material, write to Handy and Harman, Bridgeport, Connecticut, and ask them how it should be shipped.

You won't get rich by this process, but it is better than saving string. Further, you will have the satisfaction of having reclaimed a valuable metal and demonstrated the reversibility of this chemical reaction:

$$Ag^+ \quad \text{plus 1 electron} \quad \rightleftharpoons \quad Ag^\circ$$

$$\text{(silver ion)} \qquad\qquad\qquad \text{(silver)}$$

OPTICS AND IMAGE QUALITY

46.CHECK YOUR F-NUMBER

Lens aperture settings are ordinarily accurately marked, but check them anyhow.

Take the back off your camera. Set the lens at infinity. Put a small lamp (penlight, etc.) at the center of the film plane, at the focal position. Set the lens at its widest aperture.

In the dark, stick a piece of enlarging paper (sensitive surface facing the back of the camera) on the front surface of the lens.

Switch on the light for a few seconds. Put the paper in a safe envelope.

Repeat the experiment at other aperture settings.

Process the images, and measure their diameter.

Divide each of the diameters into your lens focal length. The resulting value is the actual f-number. Compare your results with the marked values.

If you find differences between the experimental values and the marked values, what assurance do you have that experimental error is not the cause? What will you do if the images are not circular? (If you fail to get an image give the paper a longer exposure.)

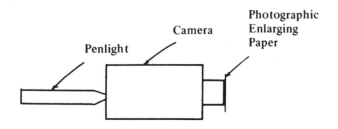

Penlight Camera Photographic Enlarging Paper

47. CHECK YOUR FOCUSING SCALE

You can test your distance setting and find depth of field in the same experiment. Use a yardstick as a test object. Place it at a slight angle to the camera axis, with the 18″ mark at the distance focused on. Make three pictures with the lens distance setting at the shortest possible: lens wide open, lens at a middle aperture setting, lens stopped all the way down. After processing, make two prints from each negative: one at your usual magnification, and one at a big blow up. Look at the prints: for those wide open, is the 18″ mark the sharpest, or is the best focus elsewhere? Find the nearest and farthest marks that are sharp enough; the difference in these readings is the depth of field. It will be surprising if you do not find that print magnification makes a difference in the results. The depth-of-field tables in the references are for normal viewing distance, which is approximately the lens focal length times the print magnification.

Repeat the experiment at different distances from the target. You may need a few yardsticks if you get very far away.

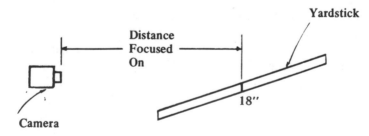

48. LIGHT FALLOFF

The design of a slide or movie projector takes remarkable care. Test your equipment for variability in light level across the screen. Focus the projector with a slide, then remove it. Measure the light level at the center of the illuminated area and at the corners. If you have no more than a two-to-one variation in light level, you have a well-designed projector. If the optics have not been recently cleaned, clean them and repeat the measurements. It takes only a little dust on lenses to change the light level by an appreciable factor. Often it is almost impossible to see the non-uniformity. Why?

Make a similar test on your enlarger.

49. CHECK YOUR LEAF SHUTTER

The marked time on your shutter is defined as the interval between the half-open and half-closed positions of the shutter, as indicated in the sketch. You can approximate the working time of your shutter by the following. Put a penlight near the rim of a 33 1/3 rpm record player. Support your camera over the player turntable, about 3 feet above. There must be enough room light so that the spindle of the player makes an image on the film. Work at the widest aperture, and at the infinity distance setting. Turn on the penlight, turn on the turntable, and make an image at a marked time of 1 second, Shift the camera position laterally and make another exposure at ½ second. Repeat for another setting. Change film and go through the process for other settings. Process and enlarge the images. The penlight will form images which are arcs and which pinch out on each end. Measure the angle between the points which are halfway between the beginning of the trace and the place where it is at its full width. Knowing the speed of the record player you can figure out what the actual time was.

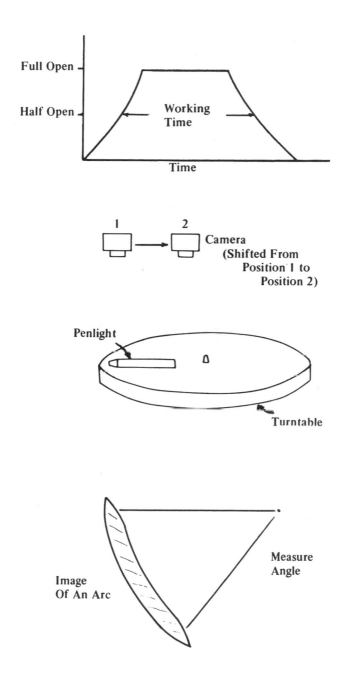

Full Open

Half Open

Working
Time

Time

1 2
 Camera
 (Shifted From
 Position 1 to
 Position 2)

Penlight

Turntable

Image
Of An Arc

Measure
Angle

50.TILT

Make a series of pictures of a tall object—building, silo, tree, etc.
—from various distances, changing the angle of the camera axis to
include the whole structure. Note the changing convergence of
vertical lines. Make prints so that the base of the structure is the
same dimension in all, and note how the upper part of the struc-
ture changes in appearance. Which of the images best gives the
impression of the "proper" shape? Which best gives the impres-
sion of extreme height?

Tall
Object

Camera at 3 different angles:

1 2 3

51.STRAIGHTEN UP

Pick one of the negatives from Experiment 50. The negative
should show a moderate degree of vertical line convergence. Make
a straight enlargement. Make another enlargement on a tipped
easel. Observe, before you make the print, the way in which the
convergence of the lines alters as you change the direction and
amount of the easel tip. Note that you need to stop the enlarger
lens well down to get enough depth of focus over the whole
image.

Enlargement made on a tipped easel

Observe in the finished print that, although you may be able by this method to correct a moderate amount of convergence, the image is by no means an accurate reproduction of the subject.Why?

52. PREDICTING EXPOSURE TIME

In projection printing, if you have found by trial the correct exposure time for one magnification, you can predict the necessary exposure time for a different magnification. The rule is that the exposure time must vary as the square of the magnification plus 1, i.e., as $(m + 1)^2$.

For example, if you enlarge a 35mm negative to 4 x 5 (without cropping) your magnification is about 4 times. (Note that it is the *linear* dimension that gives the magnification, not the area.) Suppose you find that a ten-second exposure time gives you a good print. If you now want to make an 8 x 10 print of the same negative, the new magnification will be about 8 times. For the two situations find $(m + 1)^2$. In the first case it is 25, and in the second 81. The ratio of these two numbers, i.e., 81/25 = 3.2, is the factor by which the exposure time must be changed. The new exposure time thus should be 32 seconds.

Test the validity of this rule in your equipment. Note that the inverse square law does not work in this situation. Figure out why it does not apply. You may want to refer to Experiment No. 5.

53. PHOTOGRAPHING WITH A MICROSCOPE

Photographing with a microscope is an exceptionally challenging job. Success requires good equipment, patience and considerable experimentation. The results can be most rewarding. A good microscope is a must. Do not try to make pictures with microscopes costing only a few dollars—you will be disappointed. Work first with the lowest possible power, and go to higher magnifications

only after you have mastered the optical and photographic problems at low powers.

The optical axes of the microscope and camera must be precisely aligned and coincident. Even a small error will cause the process to fail. Rigidity is also important. If you do not have a sturdy tripod, make a wooden jig to hold the camera steady. See the sketch. Focus the microscope to project an image of the slide

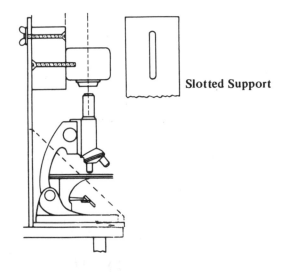

Slotted Support

STURDY SUPPORT FOR CAMERA & MICROSCOPE

on the ceiling. You will need a good illuminator. Set the camera aperture wide open, and the distance setting at 25′. The camera lens front surface should be about ½″ above the microscope, or at the position of the smallest emergent beam of light from the microscope eyepiece.

Run an exposure-time series, making careful records of lamp position, etc.

You may well find that even the best image is sharp only in the center of the field. This you cannot help, so plan to crop the negative accordingly.

Good subjects are insect fragments, feathers, hairs, fabric fibers.

54.RESOLUTION

A resolution test is done with a standard target, like the one printed with this experiment.

Photograph the target, and then look at the negative under about 20x magnification. Find the smallest distinguishable pattern. The number of lines per millimeter of film you can just see gives the resolution.

This test is by no means a lens test, since the results will vary with every important change in the process. Instead, a resolution test involves the whole photographic system. For instance, you must use a tripod or otherwise be sure the camera is rock steady.

Put the target at 21 times your lens focal length. The target will then be reduced by a factor of 20 times on the negative. Under these conditions, the largest line pattern (number 1 in the group marked −2) is then reproduced as 5 lines/mm. To find the number of lines/mm for the next smaller set (marked 2 in the group −2) multiply 5 by 1.12. This same factor is maintained throught the target. The coarsest pattern in the next group

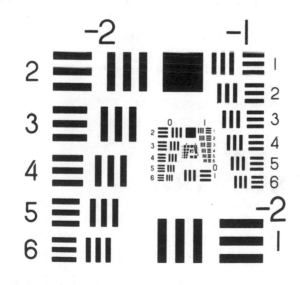

HIGH CONTRAST RESOLVING POWER TARGET

(1 in the set – 1) has twice the number of lines/mm of the biggest group in the target. And so on.

As the first test, place the target at the right distance in the center of the field. In the negative, check the biggest pattern to see that it is sharp. If not, you have a focus error which you must reduce. Repeat the test with the target at different distances, but with the same lens distance setting as before. One of these should be sharp enough. When you get a good negative, find the smallest set of lines you can detect, and figure out the resolution. 20 lines/mm is pretty good.

55. MORE ON RESOLUTION

The preceding experiment can, with changes, go on and on. Try an exposure series to see if resolution changes with camera exposure settings. Keep the same aperture; change the exposure time.

Once you find the optimum exposure level, find out how resolution changes when you put the targets at the corner of the field instead of the center. Are horizontal and vertical bars differently resolved?

Try different developers. Does fine grain developer give better resolution?

Try different f-number settings, changing the time appropriately. A good lens will give best resolution one or two stops below the maximum opening or may give the same resolution over a range of f-numbers.

56. STILL MORE ON RESOLUTION

Test your printing system to see how resolution changes from that in the negative. Pick the best negative from the preceding experiments, and make prints by enlargement. You must calculate the magnification to know the target resolution on the print.

Try different enlarging lens apertures, different print exposures, different paper grades. Sometimes resolution is actually gained in the print if the print is made on high contrast paper, but usually some resolution is lost.

57. AVOID BLUR

It takes an unusually steady hand plus good technique to avoid blurring an image, even at fairly fast shutter speeds. It is worthwhile to check your own technique. Use as a subject the resolving test chart, or other subject matter of high contrast and fine detail. Make one exposure using a tripod—a good one—or supporting the camera on a firm base. Use a shutter release or self timer to avoid camera shake. Then make handheld exposures at shutter times of 1/25, 1/100 and at as fast a speed as you have available, changing the aperture appropriately. Compare the images for sharpness. Note that the experiment will show no difference if you are out of focus.

58. BLUE CAN BE BETTER

Find out whether or not resolution in the negative changes with the color of light you use in making the exposure. Use the resolution test target. Make an image with no filter, and another with each of the filters you are interested in. Red, green and blue are good to use. (You need to know the right filter factors as found out by Experiment 61). If you find differences in resolution, you may suppose that the lens works differently with different colors of light. You will need to test very carefully to find any difference at all with a good lens. On the other hand, no lens is perfectly color corrected, so small differences are to be expected.

59. GRAININESS

Graininess is the appearance of nonuniformity in a supposedly uniformly exposed and processed area of a negative or print. Thus this concept is a subjective one. The direct method for comparing graininess is in terms of the greatest magnification the image can stand before it begins to look grainy. The bigger the magnification,

compare, for example, two different films for graininess, use the following method:

1. Choose a reasonable subject, not too full of fine detail. Graininess is seen most readily in large uniform areas.
2. Expose samples of the two films normally and process in your standard fashion.
3. Make matched prints at high enough magnification so that the prints look grainy when examined from close up.
4. Support the prints in good light at such a distance that grain cannot be seen.
5. Walk slowly toward the prints, and note the distance at which you can first see the grain. Since this distance is proportional to the visual magnification, the bigger the distance the grainier the print. You had better repeat this process to reduce measurement errors.

Many questions can be answered by slight modifications of this method. Some are:

Do observers differ in their judgement?
Does negative exposure level make a difference?
Does processing time make a difference?
Does the type of developer make a difference?
Does subject matter make a difference?

FILTERS

60. MAKE YOUR OWN FILTER

You can make filters with properties entirely different from any of the hundreds ordinarily available. From glass or, more easily, pieces of plastic, make rectangular cells about 4″ x 4″ x 1″. The 4″ x 4″ sides should be smooth and parallel, and the joints must be accurately made so that they can be cemented water-tight.

Fill the cell with water, and add dye. Food-coloring dyes or fabric-tinting dyes would be appropriate. Many colors are available. Make a series of landscape shots with colorful flowers or foliage or buildings through, for example, a filter series with more and more yellow dye in your filter cell. Note the change in the reproduction of the subject. Do the same experiment with other dyes, like red or magenta or cyan. You can mix dyes to get many different filters.

Large cells made in the same way can be used to filter artificial lights to produce interesting color effects on color film. The addition of dyes to such a filter cell over the camera could be used to make a color motion picture in which the color gradually changes during the scene.

61. THE THINKING MAN'S FILTER FACTOR

Use a Reflection Gray Scale as the subject. See that the gray scale is uniformly lighted. From as close a camera position as possible, make one normal exposure without a filter. Make an exposure series with the filter under test, bracketing the published filter factor for the film and light source you are using; i.e., if the filter factor is said to be 3x, try a series of 1.5x, 2x, 3x and 4x exposures.

Process normally. Trim the negatives so that you can place the gray scales side-by-side. The filter negative which best matches

the no-filter negative gives you the necessary filter factor in stops. Measure and plot the gray scale images.

Try this experiment with different sources: bright sun, overcast daylight, tungsten light, fluorescent light.

Try panchromatic and orthochromatic film.

If you use a red filter, you will have trouble getting a filter factor with orthochromatic film. Why?

62. PAINT CHIP TARGET

Obtain a few paint chips from a hardware store. The chips should be as large as you can get, and of a variety of colors. Photograph these with no filter, and with the filters for which you already know the right filter factors. Compare the way in which the different patches are reproduced in the negative and in the print.

Make a game out of this experiment. Identify the filters but not the colors of the patches, and challenge your friends to figure out what the color patches were. Or, identify the colors of the patches and ask the observer to say what the filter was.

63. FILTERS AND LIGHT SOURCES

Repeat the experiment with paint chips, using different light sources: daylight, fluorescent lamps, tungsten lamps.

Can you see the differences in the way different colored originals are reproduced?

Try different films, i.e., of different spectral sensitivities.

64. IS YOUR SAFELIGHT SAFE?

Safelight filters, like other filters, may fade in time. Since light fog damages print quality, you should from time to time check your safelight.

For this test, use your fastest photographic paper. Put an unexposed sheet in a place where it receives a reasonable illumi-

nation from the safelight. Turn on the safelight, and wait one minute. Cover about a third of the sheet with an opaque card and wait one more minute. Finally, cover two-thirds of the sheet with the card and wait another two minutes. Thus you have three areas of the photographic paper which have received light for times of 1, 2 and 4 minutes. Process the paper normally and examine it for even a faint darkening.

Another method is this: find out by trial the exposure conditions, using a uniform illumination from your printer, that give a medium gray on your fastest photographic paper. Once you have found these conditions, give another sheet of paper the same exposure but do not process it yet. Put the exposed sheet where it receives a normal intensity of light from the safelight, and put an opaque object like a coin on the sheet. Expose this arrangement to the safelight a little longer than you normally do when you are making prints and then process the paper. If you can see an image of the coin, you are getting safelight fog.

Why is this second test probably more sensitive than the first one? Would the second test be more or less sensitive at a much lower density level? Why?

65. POLARIZING FILTERS

Use polarizing filters to reduce unwanted reflections from glass, water, varnished, painted surfaces. (Metallic surfaces are no good for this experiment.)

A requirement is that the camera axis be at about 50° to the perpendicular to the surface. To position the filter properly, look through it from close to the lens position, and rotate the filter until the unwanted reflection is at a minimum. Then carefully transfer the filter to the front of the camera lens without changing the filter orientation.

Use the polarizing filter to photograph shop windows, aquariums, to see down into clear unruffled water, etc.

Use a filter factor of one stop. Since polarizing filters are nearly neutral, this is one case in which a single filter factor works under all circumstances.

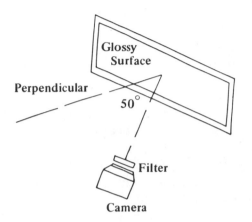

66. FILTERS TO TRY

Good photographic filters are expensive, and deservedly so because of the care that is put into their manufacture. Plastic and cellophane (such as is used for wrapping gifts) come in a variety of colors. Try pieces of such materials as filters. The reds and yellows will probably work well; the greens and cyans will probably be relatively poor.

Test the filters by using your paint chip test object. A preliminary visual examination will help to screen out the really poor filters.

67. OPTICAL STAIN REMOVER

Do you have an old photograph around the house that you treasure, but that has become spotted yellow with age? Here is a way to restore it. Make a copy negative of the photograph through a yellow filter. Be sure to increase your camera setting to compensate for the filter attenuation. If for some reason you want to enhance the yellow spots make the copy negative through a blue filter. A good exercise would be to shoot the stained photograph through no filter as you would normally make a copy negative, then through a yellow filter and then through a blue filter. If you are not completely satisfied with the results of the yellow filter, try different colored yellow filters. If you had a print with a blue stain what filter would you use to remove the stain? Try copying a color print through different colored filters. In all of the above be sure to use a panchromatic film.

68. BE A CLOUD MAKER

Photograph a cluster of beautiful clouds in the sky without any filters and the film will not record the beauty you see. If you want the clouds in the print to be natural in their likeness try a Wratten 8 Yellow filter. To exaggerate somewhat, try a Wratten 15 Deep Yellow filter. For really spectacular results, use a Wratten 25 Red filter. Try these filter factors:

Wratten 8 Yellow (K2)	1.5 times
Wratten 15 Deep Yellow (G)	3 times
Wratten 25 Red (A)	8 times

For other recommendations on subjects such as marine scenes, sunsets, distant landscapes, outdoor portraits, architecture, etc., refer to the Kodak booklet on "Filters and Pola-Screens."

Why do the yellow and red filters provide contrast between the blue sky and the white clouds? What would happen if you used a blue filter?

CLOUDS

69. BE SELECTIVE

You can keep your lighting ratio and your development constant and selectively change the contrast of a scene. Consider the following subjects:

Red apple, yellow banana, orange orange, green pepper and blue sky.

A photograph of such a scene under a specified lighting contrast and development time would produce a print of specific contrast. If you want to lighten the red apple in the print shoot through a red filter. To lighten the orange orange shoot through an orange filter, etc. An alternative way is to use a film that is non-red sensitive such as an orthochromatic film. If you want to lighten all the colors but blues try a blue sensitive film. If you were to substitute a red tomato, yellow lemon and a green lime in the scene would you expect the results to be different? How would you go about trying to predict this?

UNUSUAL LIGHT SOURCES

70. BY THE LIGHT OF THE SILVERY MOON

Moonlight is not much different from daylight. Test out the truth of this statement by making landscape pictures by the light of the moon. Since the light is feeble, think big about the required exposure time. Set your lens wide open, and try an exposure series 1000x, 10,000x, 100,000x and 1,000,000x the time you would use in daylight. Then do a second experiment, if necessary, to pin down the required exposure time. First use fast black-and-white film. Then, when you have acquired experience, try color film. Naturally, the phase of the moon is important. Winter shots are easier because the snow cover helps.

71. BLACKOUT PHOTOGRAPHY

Use infrared-sensitive film and infrared flashbulbs to make really candid shots in the dark. Follow the manufacturer's recommendations for exposure settings. Theater audiences make good subjects. Notice the way skin tones are reproduced as compared with normal black-and-white materials exposed with light.

Try similar film with an infrared filter and tungsten lamps to photograph the superficial blood vessels in human skin. Use the same kind of film and filter for landscape photography. Fall shots are especially interesting. Green painted houses and green foliage reproduce quite differently with infrared film. Find out why.

72. SHOOT INTO THE SUN

Place your subject directly between you and the sun or whatever source of light you are using. If you want a silhouette set your camera as you would normally do when you are not shooting into the sun. If you want to obtain some detail in the subject area use fill in light from reflector or flash. Try different angles and include various amounts of the sun directly into your camera.

REFLECTIONS

(CAUTION!) Do not look directly into the sun or into your camera if it is pointed directly at the sun.

COLOR

73. NOTHING IS PERMANENT BUT CHANGE

Manufacturers of color photographic materials are careful to warn the customer that all dyes fade in time. You can make a rough test of the seriousness of this problem by covering one half of a color print with heavy opaque paper taped to the print, and fastening the whole print facing out toward daylight. Examine the print from time to time over a period of a few weeks. Compare a transparency and a print with respect to dye stability. If you do your own print processing or transparency processing, test the effect of final wash time on image permanence.

These experiments will convince you of two things: if you want your color images to look good for a long time, store them away from light; good processing methods are necessary for image stability

74. HOW NEUTRAL IS COLOR FILM?

A critical test for a color film which has been exposed and processed correctly is a reproduction of flesh tones and a near scale of neutral colors. Take a few pictures of a friend holding a gray scale and a gray card. The picture you get should have a pleasing flesh tone and a *scale* of near neutral colors. This is true whether you are looking at a transparency or a print. If the flesh tones or neutral tones are not as you expected, is this because of the film, the exposure of the film, the processing or a combination of all three? It is most likely the exposure and/or processing of the film.

75. RLF AND COLOR FILMS

When extreme exposure times are used for color film (or any photographic films or papers) the result is reciprocity-law failure. With a color material this could mean a shift in color as well as a loss in density and a change in contrast. Have a friend hold up a gray card and a gray scale and photograph him (or her). Do this at equivalent camera settings, changing only the shutter and f-stop

together. You might try speeds of 1/1000, 1/125, 1/10 and 1 second. Avoid using any neutral density filters if you can since these will give a slight yellow shift in color. (A 0.30 ND filter is equivalent to 1 f/stop.) After you make one set of exposures, repeat them to establish whether the differences you observe are due to RLF or just variability of your camera, or both.

76. MAKING BLACK-AND-WHITE NEGATIVES FROM COLOR TRANSPARENCIES

Project a color slide on a screen, preferably matte. Place your camera near the projector. Make meter readings as if you were working with the original scene. You will probably need to bracket your estimated exposure settings to get a good image. Transparencies are likely to be quite contrasty, so you may need to cut your negative processing time to reduce negative contrast.

You can use filters to change the color rendition in the negative. Refer to Experiment No. 68.

You can crop the image by moving the camera closer to the screen. (This may require an exposure change.)

You can do combination printing of two transparencies, either by putting two images into the projector together, or (more easily perhaps) by successive projection. You may mask off portions of one or both transparencies.

RENÉE

Black-and-White print from a Color transparency

77. COLOR REPRODUCTION

Use the same paint chips as in Experiment 62 to see how color processes reproduce colors.

Make a transparency of the set of chips, project it, and compare the projected image with the original alongside. You will need to think about how to illuminate the chips when you view them.

Compare the reproduction of red, green, blue, yellow, etc.

Compare the reproduction of pastels with saturated colors. (Note well: no commercial color process can reproduce all colors exactly. Every process necessarily compromises in order to make a pleasing, as distinct from a faithful, image.)

Do a similar experiment with color prints. Compare the print with a reversal transparency.

78. WHAT COLOR IS THE CAT?

Photograph a white cat on a black background (or any white object against a dark background) using your favorite color film. Include a Color Separation Guide. Then put a red filter over your lens, allow for the attenuation of light of the filter (i.e. filter factor) and take another picture. If you do not have any photographic filters just use any red transparent material. Make an exposure series to compensate for the attenuation of light by the filter. If you use a Wratten 25 filter and are shooting under daylight conditions, try increasing your exposure by about 3 stops. Example: If your camera setting is 1/60th at f/11, try 1/60th at f/4. Try green, blue, and other color filters. Did the color of the black background change?

79.WHAT COLOR IS THE CAT?(#2)

Make a color transparency of a white object—cat, fabric, mouse, etc.—against a green background like grass. Include a Color Separation Guide. Make a second transparency with a red filter over the camera lens, with an appropriate filter factor. Compare the two images, and account for the difference in appearance of the white and green objects. Alternative experiment: use the paint chips of Experiment 62 as test objects, and make transparencies unfiltered and with different dye filters, observing the change in the way in which the chips are reproduced in the transparencies.

80.SABATTIER EFFECT BLACK-AND-WHITE AND COLOR

The Sabattier Effect is observed as a partial or complete reversal of tones and it is most dramatic in the shadow areas. In addition there is often a line effect present. Compare the two prints shown; one is a print from a normally processed negative and the other from a negative that has undergone the Sabattier Effect.

Any film, black-and-white or color, can be used. Try this proced for reversing a black-and-white or color negative:

1. Expose the film to a strongly lighted subject. Include a lot of shadow area, if you want dramatic results.
2. Develop the film for about half the usual time.
3. Rinse the film in water.
4. Re-expose the film to a weak light. Try a 25-watt tungsten lamp in a safelight housing (no filter). Bounce the light off a ceiling for a exposure time of 20 seconds.
5. After the re-exposing light has been turned off return the film to the developer and develop the film for the remainder of the usual ti
6. Take the film out of the developer and complete the usual sequence of processing.

PRINT FROM A NORMALLY PROCESSED NEGATIVE

PRINT FROM A NEGATIVE THAT HAS UNDERGONE SABATTIER EFFECT

7. Print the negative. Some shadows that you would expect to be dark in the print will be lighter than some midtones, i.e., some of the tones will be reversed. (For the color negative film if you want the shadow areas in the color print to be red, green or blue simply use a red, green or blue filter over the light source or negative when you re-expose the film (step No. 4). Try a 100 watt bulb instead of a 25.)

If you want to obtain more reversal of tones decrease the time of first development and increase the time of second development. If you include a reflection gray scale in the subject area when you make your camera exposure, you can make density measurements of the negative (see Experiment 10) and of the print (see Experiment 9).

A D-log E curve characteristic of the Sabattier Effect is shown by the dotted curve below. Compare it with the solid curve which represents a normally processed negative. Notice that except for the shadow areas both curves are alike. This graphically represents the partial reversal of tones characteristic of the Sabattier Effect.

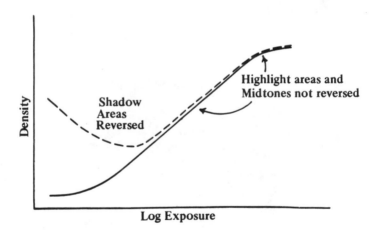

D-Log E curve showing partial reversal (dotted curve)

For more information on the Sabattier Effect and similar photographic phenomena refer to *Photographic Sensitometry*, by Hollis N. Todd and Richard D. Zakia, Morgan and Morgan, Hastings-on-Hudson, N.Y., 1969

81.COLOR NEGATIVES FROM BLACK-AND-WHITE FILMS

The next time you go out to shoot some 35mm black-and-white pictures save some frames for this experiment. Pick out a scene that has an interesting variety of colors and is stationary. Set your camera on a tripod and take 3 pictures; one through a Wratten 25 red filter, one through a Wratten 58 green filter and, the other through a Wratten 47B blue filter. Here are some filter factors to try when you expose through these red, green and blue filters.

		Outdoors	Indoors
Wr25	Red	8 times	6 times
Wr58	Green	8 times	8 times
Wr47B	Blue	8 times	16 times

Remember that each camera setting is a factor of 2 so if you want to increase your exposure by a factor of 8 times open up 3 stops ($2^3=8$). You will want to bracket one stop over and one under for each filter.

After you have the slides processed and mounted, put each one in a projector (you will need three) and project them through the same filter you used to expose the slides. You will see on the screen, after you have properly registered the slides, a *color nega tive* of the scene. The red hues in the original scene will look cyanish, the greens, magentaish, and the blues, yellowish. Why does your color negative not look orangish as a Kodacolor negative? See Experiment 82 if you want a color positive.

82.COLOR POSITIVES FROM BLACK-AND-WHITE FILMS

To make a set of 3 positive slides that you can project to form a positive color slide take each of the 3 negatives you have from Experiment 81 and make contact transparent prints. Be sure to identify the slides as the red, green and blue record. You now

have a black-and-white positive made from each of the black-and-white negatives taken with a red, green and blue filter. Project them the same way you projected the 3 negatives in Experiment 81. It is important to register each slide as best you can (there will be a slight parallax problem) and to adjust the intensities of the 3 projectors as needed. This can be done with neutral-density filters or by using a rheostat. Do the colors on the screen satisfy you? If not, describe in what way they are deficient and think how you might improve your color slide. Is it important for the contrasts of the 3 positive black-and-white transparencies to be the same? They were not the same in the negative even if they were processed together.

Try different combinations of filter-slide projections. Project the red record slide through a green filter; the green record through a blue filter; and the blue record slide through the red filter. This is the basis for what is called "false color systems" in photography. Try predicting what colors will be formed when other combinations are tried.

PICTORIAL EXPER-IMENTS

83. PHOTOGRAPHS WITHOUT CAMERAS

Photograms are images formed by shadows of objects, made directly on the photographic material without the aid of optical gadgets. All you need is a light source and a sheet of photographic

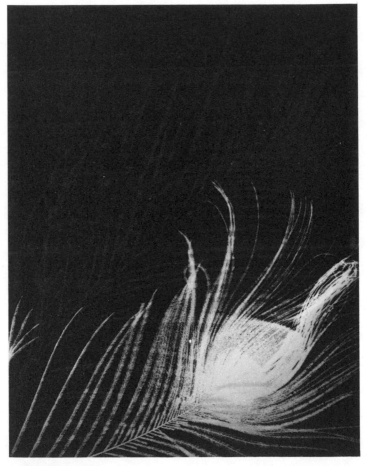

PHOTOGRAM

paper. Place the object in the light path, turn on and off the light, and process. Try different lamps like flashlights, clear tungsten lamps, frosted lamps, fluorescent lamps, etc. Try opaque and transparent objects like ashtrays, keys, coins, leaves and other found objects, tree branches. Profound changes in the image result from changes in the distance of the object from the lamp and from the paper, and from changes in orientation of the object.

You could make a game out of a series of such pictures of familiar objects.

84. A LIGHT BOX IS MANY THINGS

Moholy-Nagy, the great artist of the Bauhaus days, made interesting and beautiful pictures by the aid of a lightbox. The box consists merely of a slotted or perforated board, illuminated from one side; the object to be photographed is placed on the other side. The array of light patches on the object gives a remarkable feeling of depth, and at the same time reveals form in an unusual way. Make pictures of still life assemblages and of persons with this kind of lighting. A venetian blind would be easy to use. Or make the slotted arrangement from lath. Try perforated hardboard. Experiment to find the difference in effect between spotlight and floodlight illumination. Try daylight coming through a window.

85. PHOTOGRAPHIC OP ART

Make an image consisting of concentric circles or triangles or squares or hexagons or what have you by this photographic method. Cut the shape out of black paper and put it in your enlarger in the negative carrier. Start at the biggest possible magnification, and make a short exposure on a sheet of enlarging paper. Remove the paper, change the magnification of the image and re-focus, put the paper back and make another exposure. Repeat this sequence, changing the magnification as you like. You will wind up

with a print which can be used as a negative to make a contact print with reversed tones.

If you make a few of these op images with different shapes, you can combine these, by using them as negatives, to make a great variety of images. Try slightly out-of-focus original exposures for a different effect.

86. THE ILLUSION OF MOVEMENT OR SPEED

Photographers often try to arrest the movement of an object by using a fast shutter speed like 1/250th or so. Oddly enough, the crisp sharp pictures you obtain of a moving object do not provide the feeling of movement. Try shooting a moving object so as not to get a sharp picture. Try for just enough blur to allow identification of the object and the illusion of motion. You will have to try a few different shutter speeds depending upon the movement of the object and the distance of the object from your camera position. Objects in motion perpendicular to your camera will have the greatest movement with respect to your camera.

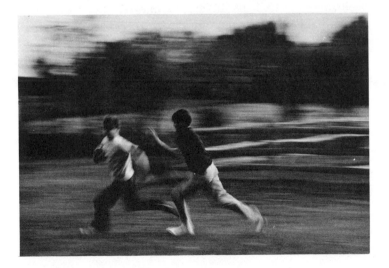

87. PAN IF YOU CAN

This can provide an illusion of movement or speed. If you want to take a picture of a moving object, want it to be sharp and yet portray a feeling of movement or speed, set your camera sights on the moving object and move the camera with the object, always keeping it in your view. This can be done off a tripod but you will obtain better results if you can pan with a tripod or equivalent support. The blurred background will give you the illusion of movement.

88. HYDRO-SCULPTURING

Walk to a creekbed and watch the water flow. Take a picture of it at a fast shutter speed. Then do the same at a slow shutter speed, about 1/10th of a second or so. Use a tripod if you can. Compare the two pictures. You will note that the picture taken at the slow-

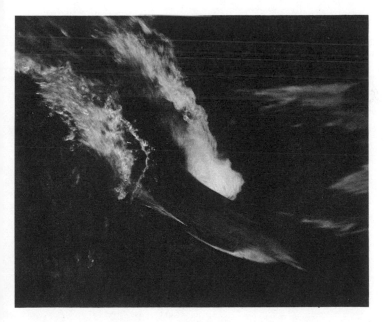

er shutter speed did not arrest the movement of the water but rather allowed the reflection from the moving water to blur the picture, giving a feeling of sculpturing. Try it with small waterfalls or Niagara Falls if you are in the area. Try a variety of shutter speeds to get just the right amount of blurring.

89. MAKING PEOPLE DISAPPEAR

Most photographers make pictures at very short exposure times. Try the converse—making pictures with exposure times of minutes. Stop down your camera as far as you can. Use a slow film. Use town streets as subjects—you can make the traffic disappear and the streets seem deserted, since swiftly-moving objects will not be recorded. Pedestrians may appear as ghostly figures.

VISION AND ILLUSIONS

90.VERTICALS AND HORIZONTALS

In the early twenties, psychologists of the school known as "Gestalt" were deeply interested in the visual process, and especially in illusions. One involves the apparent difference between the lengths of equal vertical and horizontal lines:

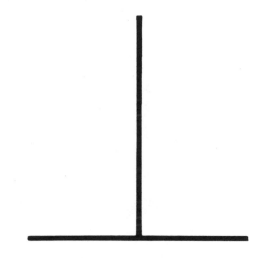

Experiment with this illusion. For example, does it hold for thick objects—pencils, candy bars, film spools? Need the two objects be identical? Need they be perpendicular? To make two objects *look* the same length, how must their actual lengths compare? Ask a few people to make a drawing like that above, but so that the lengths look the same, and then measure them. Does the illusion hold if one line is at the end of the other rather than in the middle? Does the illusion hold for a cross? Think of other variations on this simple illusion and try them out.

The application is of course to problems of design in the graphic arts as well as in photography, architecture and other areas.

91. FIGURE-GROUND RELATIONSHIPS AND GESTALT PSYCHOLOGY

Every photographer should know a little something about the
concept of figure-ground relationships, an important aspect of
Gestalt psychology which had its beginnings in Europe back in
1912. The concept is a simple one to understand, illustrate and
use in picture taking. Below are three mirror-image contour lines.
What you see is what you want to see and depends upon what
you consider to be the figure and what you consider or want to
be background. If you want to improve your perception of figure-
ground, decide what you want to see. For example, if you want
to see the shape between the mirror contour lines, shade them in.
Try just the opposite shading. Do you find that by concentrating
on the picture that you can see either a pair of mirror profiles or
a pedestal? If you see the pedestal then you have decided that it
is the figure and the rest is background. Is it possible to see both
the pedestal and the profiles at the same instant? To pursue the
subject further pick up any general psychology text on the sub-
ject. For $2.25 you can buy a very useful paperback, PER-
CEPTION, by Julian E. Hochberg, Prentice-Hall, Englewood
Cliffs, N.J. Another very useful and inexpensive paperback is
EYE AND BRAIN, by R.L. Gregory, McGraw-Hill, New York.

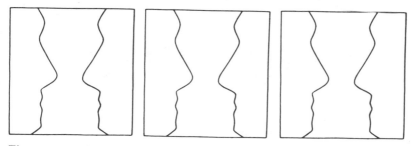

Figure—ground relationship: Profiles or Pedestal, which do you see?

92. MORE GESTALT

Two objects of the same size can appear to be different, depending upon their relationship with other objects or lines. For example, an object nearly enclosed by another usually appears larger than if it were not so nearly enclosed. Your visual perception of the two objects enclosed by about a 30-degree angle could confirm this. If not, try a similar scheme. Manipulate the objects and enclosure until you do get a difference in appearance. Try a table top setup that you can photograph and see if the print you obtain bears the same relationship to the original perception. You might use a couple of 35mm film caps. Does it make any difference whether the two objects are the same? Could you take a smaller object, put it nearest the enclosure and make it appear the same size as the larger object further from the enclosure?

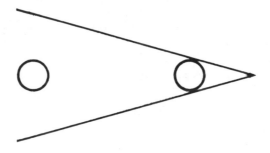

93. PHYSICAL DOMAIN VERSUS PSYCHOLOGICAL DOMAIN

With the proper background or surround, a straight line can appear curved. Place a wagon wheel or a bicycle wheel flat on the floor or table top. If you do not have such objects, simulate

Do the two Horizontal sticks appear straight or curved?

them. Lay two sticks, parallel to each other, over the wheel. Make
a photograph of it so that you are looking straight down on it.

The position of the parallel sticks with relation to the spokes of
the wheel and to each other is important for this phenomenon to
occur. Try different positions until you obtain the most pro-
nounced visual effect of the curvature of the parallel lines.

Parallel lines crossing radial lines at certain angles give the
appearance that the lines are not parallel. Which condition is best
for this? Is it possible to place two sticks that are physically
bowed on the radial lines and obtain a visual perception of
straightness?

For more information on the subject of perception see R. Evans,
INTRODUCTION TO COLOR, New York, John Wiley, 1948.
or R. Evans, EYE FILM AND CAMERA IN PHOTOGRAPHY,
New York, John Wiley, 1959.

94.WE DON'T ALWAYS SEE WHAT IS IN FRONT OF US

The organization of elements within a perceptual field influences the perception. Read the sentence in the triangle. Now read it again. Most people make a common error in reading such a sentence. Did you? How might you change the *organization* of the elements (words) to avoid such an error or make it less likely? Did you find that even re-reading the sentence did not help? Sometimes we get into a visual rut, seeing only what we saw first. We have all had such experiences and recognize that they are not restricted to the visual perception of things.

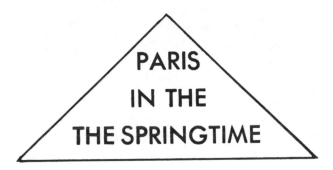

PARIS

IN THE

THE SPRINGTIME

95.NOW YOU SEE IT, NOW YOU DON'T

Here is an interesting example of figure-ground relationships. Do you see a picture or just a lot of indistinguishable patterns? If you can distinguish figure from the background, a face of a man will emerge. Some people see this quite readily, some take longer,

some find it almost impossible to see. Yet the face of the man is there. . .but then again is it there if you do not see it?

FIGURE OF A MAN

On the next page is the same figure-ground relationship but the tones are reversed. See if you can make out the face of the man.

The figure-ground relationship shown below is the same as that shown on the previous page but with the tones reversed. Can you see the figure?

FIGURE OF A MAN

Look for ambiguous figure-ground relationships in reflections from water and wet surfaces, window fronts, paint peeling from walls, clouds, etc. Photograph them for detailed study later.

96.WHAT DO YOU SEE WHEN YOU READ?

Try this proofreader's test. Count the number of letters F in the rectangle. If you would like, go back and count them again to see if you agree with your first count.

Most people do not see all of the letters F in the rectangle. This is another example of the importance of organization. A photographer can organize his subject matter so as to allow an easy perception or not. Try rearranging the words in the rectangle to make all of the letters F more easily perceptible.

Another lesson that might be learned from this simple demonstration is the importance for a photographer to know his audience. Try this demonstration on a few of your friends and on a person that does not know how to read English. The person unable to read English will probably do best. How come?

> FINISHED FILES ARE THE RE-
> SULT OF YEARS OF SCIENTIF-
> IC STUDY COMBINED WITH
> THE EXPERIENCE OF YEARS.

Answer: Most people see about three, there are six.

97.HOW HIGH THE MOON

The moon (and sun too) often looks bigger near the horizon than when it is more nearly overhead. Find out whether the apparent difference is real by photographing the full moon just after it has risen, and again later in the evening. You can make both shots on the same negative. The required camera settings will be about what you normally use for daylight landscape pictures. Make enlargements and measure the diameter of the moon's disc. For more of this kind of carrying on, see THE NATURE OF LIGHT AND COLOUR, by M. Minnaert, Dover Publishers.

98.TO SEE OR NOT TO SEE

Vision involves many peculiarities.

Set up the target below in good light. Starting about 100 feet away, walk slowly toward the target. Note the distance at which you can first correctly identify the different elements of the target. A better experiment would be to test a friend who does not know what the targets look like.

Is there a connection between the lengths of the spots and the distance at which they can be separated? Is the offset easier to detect than the separated pairs?

Make similar targets of black lines on gray paper; white lines on black paper; red lines on blue paper, etc. Which arrangement is best for detecting such spots?

99. SEEING AND NOT SEEING

Map out the "blind spot" of your eye. On a sheet of 8½" x 11" paper place a small pencil mark a couple of inches from the left side of the 11" dimension. Look steadily at that spot with your right eye, your hand over your left eye. Start with a pencil point near the mark, and move it to the right until the pencil point just disappears. (Keep watching the first mark!). Make a spot on the paper where the pencil point vanishes. Keep going to the right with the pencil point until you can see it again, and make another mark. Continue thus to find the upper and lower bounds of the blind spot. It is bigger than you think. Turn the paper around and test your left eye.

100. EVERYBODY'S COLOR BLIND

For this experiment you need an assistant. On separate small pieces of paper make colored spots—red, green, yellow, black. Seat your subject and stand behind him. Ask him to keep looking

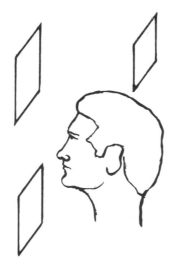

Subject must keep eyes fixed straight ahead

straight ahead. Hold one of the colored spots a couple of feet to the left of his left ear, and ask him for the color. Move the sample toward his nose until he can correctly identify the color. Repeat with different color patches and working from different beginning positions, like over his head, from the right side, and from under his chin. Thus you can map out the color sensitivity of the retina for different colors. Make sketches of the results.

101.THE CONTRAST OF A SUBJECT VARIES WITH THE BACKGROUND

If you make two photographs of the same subject under identical conditions, except for a change in the background, you will change perception of contrast.

Place a reflection gray scale on a black background, photograph it, and then make a good print of it. Using the same camera settings, photograph the same gray scale using a white background. Use the same printing conditions used for the gray scale on the black background to make the print. Compare the prints side by side. Has the *lightness* of the tones changed? Has the *contrast* changed? Fill in the table below and look for a pattern of change. Have someone else make the same comparisons independent of yours, to see if there is agreement.

LIGHTNESS COMPARISON	Midtones	Shadows	Highlights
Black Background			
White Background			

CONTRAST COMPARISON			
Black Background			
White Background			

For more information on the subject refer to C.E.K. Mees and T.H. James, THE THEORY OF THE PHOTOGRAPHIC PROCESS, New York, Macmillan Co., 1966, p. 478.

CONVERSION TABLE

EQUIPMENT LIST

CHEMICAL LIST

CONVERSION TABLE

If you do not have chemical measuring equipment, household measuring devices, such as teaspoons and postal scales, can be used as improvised substitutes.

1 ounce by weight = 28 grams
1 teaspoon = 5 milliliters (ml)
1 tablespoon = 15ml
¼ cup = 2 fluid ounces = 60ml
1 quart = 32 ounces = 960ml (nearly 1 liter)

EQUIPMENT LIST

Below are listed the few items not normally found in the home or in a usual darkroom setup:

Experiment No. 4.
Diffraction grating order No. 40,272, Edmund Scientific Co.

Experiment No. 9, etc.
Reflection Gray Scale, included in the packet Color Separation Guides at camera store.

Experiment No. 10, etc.
CdS light meter, any of several brands, as little as $25 at camera store.

Experiment No. 15, etc.
Neutral Test Cards, at camera store. Two sets will be needed.

Experiment No. 19, etc.
Photographic Step Tablet, at camera store.

Experiment No. 65.
Polarizing Filters, order No. 70,418, Edmund Scientific Co.

*For a free catalogue write to:
Edmund Scientific Co.
675 Edscorp Bldg.
Barrington, N.J. 08007

CHEMICAL LIST

The following materials, not usually found at home, can be obtained from a druggist, from a camera store, or from a chemical supply house. Before you use any of these materials, read the Safety Tips just before Experiment 31. Potassium ferricyanide is toxic. Hydrochloric acid and sodium hydroxide are injurious to skin. Some people are allergic to developing agents.

Ferric ammonium citrate
*Ferrous Oxalate
Formaldehyde
Hydrochloric Acid
*Hydroquinone
*Metol (Elon)
*Phenidone
Potassium alum
Potassium dichromate
Potassium ferricyanide
Potassium oxalate
Sodium carbonate (washing soda)
Sodium hydroxide (lye)
Sodium sulfide
Sodium sulfite
Sodium thiosulfate (hypo)

*Developing agents

REFERENCES

Following is a list of books from which you can learn about the theory and practice of photography.

From Morgan & Morgan, Dobbs Ferry, N.Y. 10522

Dictionary of Contemporary Photography, Stroebel and Todd
Zone Systemizer, Dowdell and Zakia
New Zone System Manual, White, Zakia, Lorenz
Color Primer I and II, Zakia and Todd
Photographic Filters, Stroebel
The Hole Thing, Shull
The Compact Photo Lab Index
Monobath Manual, Haist
Photographic Lenses, Neblette
Photographic Sensitometry, Todd & Zakia
Exposure Manual, Dunn

From other Publishers

Fundamentals of Photography, Neblette, Van Nostrand, Reinhold
Eye and Brain, Gregory, McGraw-Hill
Eye, Film and Camera, Evans, John Wiley
Photographic Systems for Engineers, Brown and Kosar, Society of Photographic Scientists and Engineers
Perception and Photography, Zakia, Prentice-Hall
Photographic Sensitometry, Todd, Wiley

Many pamphlets are published by the Eastman Kodak Company, 343 State Street, Rochester, New York 14650.
For a free copy of "Index to Kodak Technical Information" write to Dept. 412-L.

The following service publications can be obtained by writing to Dept. 454:
 AA-5 How to Make and Use a Pinhole Camera
 P-124 Bibliography on Underwater Photography and Photogrammetry
 C-9 Photography Under Arctic Conditions
 AC-10 Photography of Television Images
 AC-20 Astrophotography with Your Camera

The following can be obtained through your camera store, all published by Kodak:
 Filters and Polascreens
 Here's How Series
 Enlarging in Black-and White and Color
 Color as Seen and Photographed
 Photographic Papers
 Processing Chemicals and Formulas
 Infrared and Ultraviolet Photography
 Photography Through a Microscope
 Techniques in Microphotography

GLOSSARY

ADDITIVE Color reproduction by overlapping or otherwise mixing blue, green and red light. (Experiments 81 & 82.)

A.S.A. American Standards Association. The term is most often used in connection with a film speed which is based on a carefully defined point on a characteristic (D log E) curve of fixed development. Since photographers rarely in practice meet the defined conditions, the A.S.A. Speed is best used as a starting point for an exposure series. (Experiment 13.)

Astigmatism In an optical system, the imaging of a point as a pair of perpendicular short lines. (Experiment 6.)

BLUEPRINT A photographic process making use of a chemical change in a salt of iron. (Experiment 31.)

CHARACTERISTIC CURVE (D log E curve) A plot of the response of the photographic material (density) against the logarithm of the exposure (quantity of light) that the material received. (Experiment 21.)

Color (1) A visual experience apart from our experience of space and time. Color has three dimensions; hue, saturation and brightness. Colors that have no hue are called neutrals. Example: White, grays and black. Note: Black is a color. (Experiments 3, 4, 62, and 100.) (2) The characteristic of an object by which it absorbs (and thus reflects or transmits) different amounts of different wavelengths of light. Yellow objects absorb blue (short wavelength light) strongly; red objects absorb blue and green (medium wavelengths) strongly. Neutrals (whites, grays, and blacks) have nearly uniform absorption for different wavelengths. (3) The characteristic of light associated with wavelength. Long waves are red, middle waves are green, short waves are blue.

Contrast (1) For a subject, the ratio of highlight to shadow meter reading, or the log of that ratio. (Experiment 14). (2) For a negative, the highlight to shadow density difference. (Experiment 15.) (3) For a photographic paper, the log of the exposure range over which the paper responds. Scale index. (Expt. 19 & 20.)

Cyan Blue-green. The hue of one of the dyes used in most color prints and transparencies, the other two being magenta and yellow. (Experiments 66, 81, 82.)

DENSITY A measure of photographic response. For transparencies, it is the logarithm of the ratio of the light falling on the sample to the light passing through the sample. (Experiments 10 and 19.) For prints, it is the logarithm of the reciprocal of the reflectance. (Experiments 9, 15 and 16.) The logarithm is used because such a number is nearly proportional to the amount of silver or other material per unit area of the image.

Depth of field Distance, measured from the camera position, over which the subject is acceptably sharp. The distance varies with f-number, focal length and distance to the object in best focus. (Experiment 47.)

Depth of focus The permissible change in the distance of the photographic material from the lens before a noticeable loss in sharpness occurs. (Experiment 51.)

Developer A chemical solution used to convert an exposed silver halide (latent image) to silver. (Experiments 33, 41, 42 and 55.)

Diffraction Spreading of light waves, seen when light passes through a small aperture. (Experiments 3 and 4.)

EXPOSURE Technically, the measure of the quantity of light received by a photographic material; the product of the illuminance (light level) on the material and the time during which the light acts. Commonly, camera settings, i.e., f-number and time. The latter usage fails to take into account the different illuminances on the film or paper which in fact form the image. (Experiments 20, 24, and 52.)

FADING As the dyes in a photographic print absorb large quantities of energy they begin to lose their color slightly. Radiation, heat and humidity affect fading. (Experiment 73.)

Filter Transparent material (gelatin sheet, glass, plastic, etc.) which absorbs part of the radiation it receives. Basic filters are: neutral density, absorbing about uniformly through the visible spectrum; yellow, absorbing mostly blue light; magenta, absorbing mostly green light; cyan, absorbing mostly red light. (Experiment 60.)

Filter factor A number to be applied to camera settings when a filter is used over the camera, in order to reproduce neutrals at about the same level of density as with no filter. If the filter factor is 4x, the aperture must be opened up by two stops, or the exposure time must be increased by four times. (Experiment 61, 67, 69.)

F-number The ratio of a lens focal length to the effective diameter of the aperture, i.e., to the diameter of the light beam that can pass through the optical system. For a distant subject, the required exposure time is proportional to the square of the f-number. At a constant time, the actual exposure on the film is inversely proportional to the square of the f-number. (Experiment 46.)

GAMMA A measure of the relationship between image contrast and subject contrast for the straight line portion of the characteristic (D log E) curve. Mathematically, the slope of the straight line. Gamma is used mainly as a process control index. (Experiment 16.)

Gestalt We tend to perceive things as wholes and not as parts. Our perception of things depends upon our personal experiences, the information displayed, how it is displayed and how we construct or organize it. (Experiment 95.)

Gestalt psychology Refers to a theory of psychology that emphasizes the importance of perception as a first step in learning. Its origin dates back to about 1912 in Germany. (Experiment 90 & 91.)

Graininess The visual impression of non-uniformity in a uniformly exposed and processed area. (Experiment 59.)

Grayscale A scale or ruler made up of several patches of reflecting surfaces from white to black. Since the density of each patch is known, so is its reflectance. As light falls on the grayscale it is reflected in known amounts which provides a Log Exposure scale or ruler. (Experiments 9, 13, 29, and 61.)

H & D The initials of two early investigators of the response of photographic materials to exposure and to processing—Ferdinand Hurter and Vero Driffield. The characteristic curve is sometimes called the "H & D" curve. (Experiment 20.)

Hardening Process of chemical treatment of a photographic emulsion by which the image is made less liable to damage by handling or other sources of injury. (Experiments 37 & 38.)

Herschel Effect A reduction in image density when a long-wavelength (red light, for example) exposure follows an initial short-wavelength (blue, or white light, for example.) (Experiment 28.)

ILLUSION An illusion exists when, for the same event, there are differences between physical measurements and psychological measurements. (Experiments 86, 88, 90, 92, 93 and 97.)

Image (1) In optics, the intersection or apparent intersection of light rays, caused by the reflection of light by mirrors (Experiments 6 and 7.) or lenses. (2) In photography, a hidden (latent) change in a photographic material caused by the action of light or other radiation. (Experiments 35 and 36.) (3) A detectable change in a photographic material, usually measured in terms of the density produced. (Experiments 9 and 10.)

Incandescence Production of light by objects that are heated to a high temperature. Common light bulbs are incandescent. (Experiment 8.)

Infrared Radiation just longer than red light. (Experiment 71.) Note: Special filters are used in optical systems such as projectors and enlargers to absorb infrared radiation and dissipate it as heat. (Such filters are erroneously called heat absorbing filters; they are correctly called infrared absorbing filters.) (Experiment 8.)

Intensification A chemical process of increasing image density after development. Most methods of intensification will compensate for underdevelopment of the image, but fail to compensate for underexposure. (Experiment 37.)

Interference The result of the action of two or more light waves when they meet. The waves must have the same length. Colors in soap bubbles, oil films, and lens coating are caused by interference between direct and reflected waves. (Experiment 3.)

Inverse square law For a point (physically very small) light source, the light falling on a surface is less in proportion to the square of the distance to the surface. If the distance is multiplied by 10, the light is less by a factor of 100. (Experiment 5.) The law does not apply to broad sources, but holds fairly well if the largest dimension of the source is less than one-tenth the distance to the surface. (Experiment 52.)

Inverted Upside-down. (Experiment 6.)

LATENT IMAGE An invisible change in a photographic material associated with the absorption of radiant energy. The properties of a latent image are inferred from the characteristics of the developed image. (Experiments 35 and 36.)

Latitude in exposure Tolerance in the exposure of a photographic material without significant effect on image quality. (Experiments 11 and 12.)

Light That part of the electro-magnetic spectrum that provides the radiant energy necessary for vision. It ranges from about 380 nanometers to about 770 nanometers. Radiant energy which does not allow us to see is not light. Ultra-violet radiation is often (erroneously) called black light. The UV is used to energize phosphors which then emit light. Quanta of light are called photons. (Experiments 3, 4, 8, 63, and 70.)

Light meter An instrument, usually photoelectric, used to measure visible energy. Widely, but inaccurately, called "exposure" meter. (Experiment 10.)

Light value A marking on some light meters and cameras. Intervals between numbers represent factors of 2x; thus the scale is in fact logarithmic. (Experiment 10.)

Lines per millimeter The unit of resolution—that is, the detectability of closely adjacent small image elements. A "line" consists of one light plus one dark bar. To make this situation clear, the phrase "line-pairs" is often used. (Experiments 54, 55, and 56.)

Logarithm An exponent, usually based on 10. The logarithm (log) of a number is the exponent which, when used with 10, equals the number. Thus, the log of 100 is 2 because $100 = 10^2$, and the log of 1000 is 3 because $1000 = 10^3$. Logs are used in photography in connection with density (Experiments 9 and 10.) and exposure (Experiment 20.)

MAGENTA Light reddish purple and similar colors. The hue of one of the dyes used in most color prints and transparencies, the other two being yellow and cyan (blue-green.) (Expt. 81 & 82.)

Magnification (1) The ratio of a linear dimension in the image to the corresponding dimension in the object. A magnification of 4x means that all the lengths, widths, etc., of the object are multiplied by a factor of four times. (2) The ratio of image distance to the object distance, for a pinhole camera or for one using a lens. (Experiments 1, 2, and 51.)

Matte In printing papers, dull, as opposed to glossy surface. (Experiments 19 and 21.)

Microphotography Production of images at very small magnification that is, at sizes greatly reduced from the original. The converse of photomicrography, which is the production of images at great magnification. (Experiment 53.)

Milliliter Abbreviation ml. One thousandth of a liter, the unit of volume measurement in the metric system. Preferred to cubic centimeter (abbreviation cc) to which milliliter is practically equivalent, but not entirely the same. (See Table of Equivalents.)

Mirror A polished, usually metallic reflector, Flat (plane) mirrors are used to change image orientation, as in reflex cameras. Curved or concave mirrors are used as substitutes for lenses in some astronomical photography because mirrors are free from the color defects possessed by lenses. (Experiments 6 and 7.)

Monobath A processing solution that both develops and fixes the silver halide image. The method works because development proceeds faster than fixation. (Experiment 41.)

NEGATIVE A photographic image in which light tones of the subject are reproduced as dark tones, and dark tones of the subject are reproduced as light tones. (Experiment 76.)

Neutral Gray, white or black. Without noticeable hue. Reflection gray scales are nearly neutral (Experiments 9, 15 and 74.)

Non-silver Applied to photographic materi. ˙ such as blueprint and photo resists which use metals other than silver, or plastics, dyes, etc. (Experiments 31 and 32.)

Normal In photography, according to usual or recommended practice. "Normal" exposure and development are according to manufacturer's advice, but may need to be changed to fit particular equipment or requirements. (Experiments 11 and 12.)

ORTHOCHROMATIC Sensitive to blue and green light, but not to red light. (Experiments 61, 67, and 69.)

Overdevelopment Processing beyond the usual time (or at elevated temperature at normal time) resulting in increased density (and increased contrast in most negative materials.) Overdevelopment can also result from too-active developer or too-active agitation unless the time is reduced. (Experiments 11, 12, and 17.)

Overexposure The act of causing the photographic material to receive too much light or other radiation. The result is images that are too dark in *negatives,* with highlights having too little contrast, and in extreme cases may result in a type of reversal called "solarization". (Experiments 11, 12, 25, 26, and 38.)

PAN To swing a camera, usually in a horizontal direction, to follow a moving object. In motion pictures, to move the camera in the same way to cover a scene of great width. (Experiment 87.)

Panchromatic Sensitive to nearly the whole visible spectrum, that is to blue, green and red light. (Experiments 61, 67, and 69.)

Pastel Pale, not vivid, light colors. Example: pink. (Expt. 77.)

Perception A process we use to gain information about our environment, such as seeing, hearing, etc. (Expt. 91, 93, 94, 95 & 96.)

Peripheral As applied to vision, even slightly away from the normal point of best seeing. Peripheral vision varies in the ability to distinguish different colors (hues) at different points of the retina. (Experiment 100.)

Perspective The appearance to a person of objects with respect to their relative distance, size and position. (Expt. 50 and 51.)

Photogram A photographic image produced without the use of optics. (Experiment 83.)

Photomicrography The production of images at high magnification, as with the aid of a microscope. The converse of microphotography, which is the production of very small images. (Experiment 53.)

Pinhole A tiny aperture, used in simple cameras to restrict the light from an object point to a small area on the film. Pinhole images are soft (slightly unsharp) but have great depth of field and focus and perfect perspective. (Experiments 1 and 2.)

Polarized Identifying light waves restricted to a specific manner of vibration rather than being random as in ordinary light. Plane-polarized light contains waves vibrating in only a single direction. It is most easily produced with polarizing filters. (Expt. 65.)

Positive An image in which the tones of the original are reproduced in approximately the same relationship—that is light tones as light, and dark tones as dark. (The relationship is never exact.) (Experiment 82.)

RECIPROCITY LAW FAILURE When an image is made with unusually weak or strong light on the photographic material, a predicted exposure time based on ordinary conditions is incorrect. (Experiments 24 and 75.)

Rectification In printing a negative, the process of reducing the convergence of lines in the negative that were parallel in the scene. The problem arises when the film plane in the camera is not parallel to the parallel lines of the subject. (Expt. 50 & 51.)

Reflection density The logarithm of the reciprocal of the reflectance. For example, if the reflectance is 50%, that is 0.50, the reciprocal is $1/0.50 = 2.0$, and the log of 2.0 is 0.3. Thus the reflection density of such an object is 0.3. An 18% reflectance gray card has a reflection density of about 0.7. The numbers marked on the Reflection Gray Scale are reflection densities. (Experiment 9.)

Relative aperture f-number. The ratio of the focal length of the lens to the diameter of the beam of light that passes through the lens. The relative aperture determines lens "speed," which is greater as the relative aperture is larger. It also affects depth of field, depth of focus, and image quality. For excellent lenses, the image quality is better as the relative aperture is larger. (Experiments 46, 51 and 55.)

Relative log exposure The logarithm of the ratio of two exposure times or of two subject light levels. For example, if two pictures are made of the same scene at two different exposure times, the second ten times the first, the relative log exposure change is 1.0 (the log of 10.) If a model for a portrait is lighted so that one side of the face receives four times as much light as the other, the relative log exposure between the two sides would be 0.6 (the log of 4.) For the Reflection Gray Scale, the differences between the numbers on the scale can be used as relative log exposures, (Experiments 11, 12, and 14.)

Resolution The ability of a photographic or optical system to produce visually distinct small elements, usually bars. (Expl. 54−58.)

SABATTIER EFFECT A partial reversal of an image associated with a second exposure before development is complete. Often miscalled solarization, which is in fact a reversal caused by extreme overexposure. (Experiment 80.)

Safelight Darkroom illumination of a color to which the photographic material is relatively insensitive. A yellow light may be used for many photographic papers, because such light contains little blue to which papers are sensitive. A red light may be used for orthochromatic (blue-green sensitive) films. A weak green light is preferred for panchromatic films, not because the film is insensitive to such light but because the eye is highly sensitive to it. (Experiment 64.)

Scale (1) The range of log exposure to which a photographic material can respond. (Experiments 19, 20, and 21.) (2) The range of tones which a photographic material can produce. (Experiments 19, 20, and 21.)

Scale index The log exposure interval needed for a photographic paper to produce both a defined minimum and a defined maximum density. "Soft" papers have a large scale index; "Hard" papers have a small scale index. To a first approximation, the scale index should equal the negative contrast (highlight to shadow density difference). (Experiment 19.)

Sensitizers Additions to a photographic emulsion used to increase or extend its sensitivity. Additions which decrease sensitivity are called desensitizers. (Experiment 34.)

Solarization A reversal of tones caused by extremely large exposures. (Experiments 25 and 26.)

Shoulder That part of the characteristic (D log E) curve of a photographic material which is less steep than the straight line and which eventually becomes horizontal at the maximum density. (Experiments 20 and 21.)

Silver recovery The process of reclaiming silver from fixing baths or from waste emulsion. (Experiments 38, 39, and 45.)

Shutter A device to control the time of exposure, usually by the action of one or more blades (between-the-lens or before-the-lens shutters) or by the movement of a curtain with a slit (focal plane shutters). (Experiment 49.)

Spectral response Color sensitivity—the response of a photographic material to radiation of different wavelengths. (Experiments 66, 67, 68, 69, 78 and 79.)

Spectrum A display of radiation according to wavelength. The electromagnetic spectrum contains all radiation, from the short gamma rays to the long radio waves. The visible spectrum includes those waves to which the human eye is sensitive, the short ones appearing blue, the middle ones green and the long ones red. (Experiment 4.) The photographic spectrum consists of those radiations which affect at least some photographic materials: gamma rays, X rays, ultraviolet, light, infrared.

Speed A number related to the amount of exposure required to obtain a specified response (density) on a photographic material. As the needed exposure is more, the speed is less. There are many different speed measures depending upon the response specified. (Experiments 13 and 22.)

TOE That region of the characteristic (D log E) curve of a photographic material between the minimum density level and the beginning of the straight line. (Experiment 20.)

Tone reproduction The relationship between the tones in an original scene and the tones in the record made of the scene. Exact physical tone reproduction is seldom achieved or required for excellent photographic records. The Zone System is a practual way of obtaining desired control of tone reproduction. (Experiments 14, 23, 29, 30 and 77.)

Toners Chemical solutions used to change the hue of a photographic image. (Experiment 40.)

UNDERDEVELOPMENT Processing for too short a time, or with insufficient agitation or at too low a temperature or in a weak developer. The image has too little contrast. (Experiment 15.)

Underexposure The act of supplying too little light to the photographic material. In the *negative,* shadows will be reproduced with too little detail. In a print, highlights will be blank white. (Experiments 20 and 22.)

YELLOW The hue of one of the dyes used in most color prints and transparencies, the other two being cyan and magenta. (Experiments 66, 81 and 82.)

CREDITS

Experiment 27, Print made in a camera
Rick Mergler, RIT, School of Photographic Arts & Sciences

Experiment 41, Negative processed in a Monobath
Howard Mandel, RIT, School of Photographic Arts & Sciences

Experiment 68, Clouds
Gerald L. Hagner, Univ. of Cincinnati, Department of Psychology

Experiment 72, Sun Effect
Larry Butler, National Technical Institute for the Deaf at RIT

Experiment 76, Print from a 35mm color transparency
Richard D. Zakia, RIT

Experiment 80, Sabattier Effect: Black-and-White, and Color
Jean-Guy Naud, National Technical Institute For the Deaf at RIT

Experiment 83, Image made without a camera
Jean Papert, RIT, School of Art & Design

Experiment 87, Pan with your camera
Gerald L. Hagner, Boston Univ., School of Public Communication

Experiment 88, Hydro-sculpturing
Minor White, MIT

Cover Design: John O'Mara
Book Design: Rostislav Eismont

NOTES